Pre-Raphaelites

PARKSTONE®
INTERNATIONAL

Author:
Robert de la Sizeranne

Layout:
Baseline Co. Ltd
61A-63A Vo Van Tan Street
4th Floor
District 3, Ho Chi Minh City
Vietnam

ISBN: 978-1-78310-017-0

Printed in China

"The first role of art is to express truth or to beautify something useful".

— Ruskin

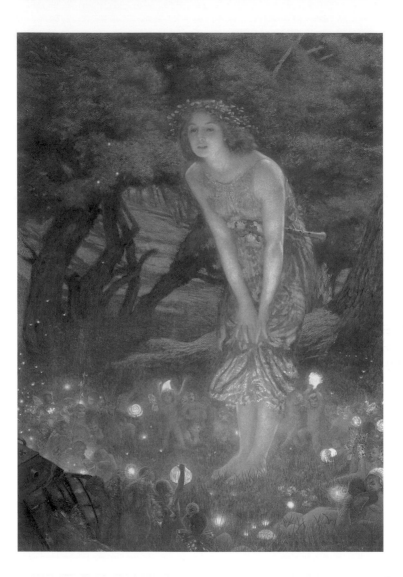

Chronology

1848: Founding of the Pre-Raphaelite Brotherhood in Great Britain by three students of the Royal Academy: William Hunt, John Everett Millais, and Dante Gabriel Rossetti. According to Millais, the Brotherhood has one aim: "The depiction of nature on canvas."

1849: First exhibition at the Royal Academy. The displayed works were signed with P.R.B. (Pre-Raphaelite Brotherhood), a monogram unknown to the public. The exhibition is received favourably.

4 May 1850: The meaning of the three enigmatic letters P.R.B. is revealed in an article in the *Illustrated London News*.

1850: Hunt, Millais, and Rossetti found the journal *The Germ*, in which they divulge the theories of the Pre-Raphaelite movement. From the first issue, they are confronted with embittered critique. The movement is defended by author and critic John Ruskin. Only four issues of the journal are printed. Rossetti leaves the group.

1851: As part of the Exhibition of 1851, Millais displays *Mariana*, Hunt *Valentine Rescuing Sylvia from Proteus*. The Pre-Raphaelites receive even more criticism for their technique. Millais completes one of his most famous works: *Ophelia*.

1852: Last exhibition year before the disbandment of the group. Millais displays *The Huguenot* and *Ophelia*, Hunt *The Scapegoat*. Their works are received with success. Contemporary and literary subjects take the place of medieval themes previously found in Pre-Raphaelite paintings.

1853: Millais is named Member of the Royal Academy. The group separates, and
 Rossetti writes to his sister: "So now the whole of the Round Table is dissolved."
 The second Pre-Raphaelite generation is represented by the works of Edward
 Burne-Jones and William Morris.

1854: William Hunt travels to Palestine.

1855: At the World Exhibition in Paris, the Pre-Raphaelites are at the peak of
 their success.

1856: Rossetti, who has not exhibited anything since 1850, presents at an exclusive
 Pre-Raphaelite exhibition, where he is greeted with enthusiastic applause.
 He displays the watercolour *Dante's Dream*, which remains one of his most
 significant works.

1860: The influence of Pre-Raphaelites, which extends to the end of the 19th century, is
 seen in the works of certain painters such as William Dyce, Augustus Egg, and
 William Powell Frith, as well as for photographers Julia Margaret Cameron
 or Roger Fenton.

1882: Death of Rossetti. His work and that of his fellow painters are representative of
 Pre-Raphaelites and will continue to be a source of inspiration for future artists
 for a long time, especially for Aubrey Beardsley.

End of the 19th century: The Pre-Raphaelite movement gradually fades. Its influence on Art Nouveau
 and Symbolism is substantial.

ENGLISH ART IN 1844

Until 1848, one could admire art in England, but would not be surprised by it. Reynolds and Gainsborough were great masters, but they were 18th-century painters rather than 18th-century English painters. It was their models, their ladies and young girls, rather than their brushwork, which gave an English character to their creations. Their aesthetic was similar to that of the rest of Europe at that time. Walking through the halls of London museums, one could see different paintings, but no difference in manner of the painting and drawing,

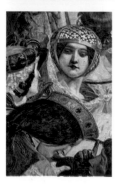

Chaucer at the Court of Edward III

Ford Madox Brown, 1847-1851
Oil on canvas, 372 x 296 cm
Art Gallery of New South Wales, Sydney

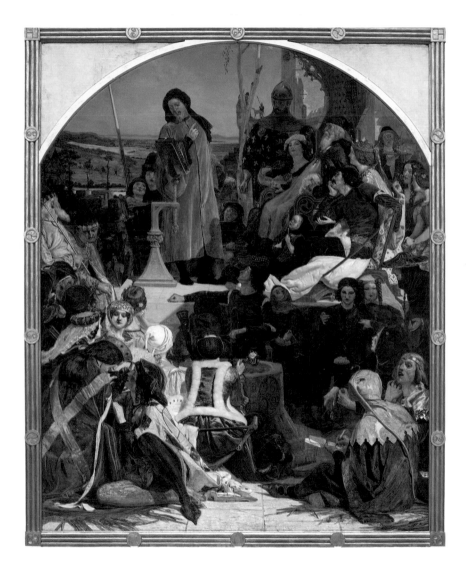

or even in the conception or composition of a subject. Only the landscape painters, led by Turner and Constable, sounded a new and powerful note at the beginning of the century. But one of them remained the only individual of his species, imitated as infrequently in his own country as elsewhere, while the work of the other was so rapidly imitated and developed by the French that he had the glory of creating a new movement in Europe rather than the good chance of providing his native country with a national art. As for the others, they painted,

The Eve of St Agnes

William Holman Hunt, 1848
Oil on canvas, 77.4 x 113 cm
Guildhall Art Gallery,
Corporation of London, London

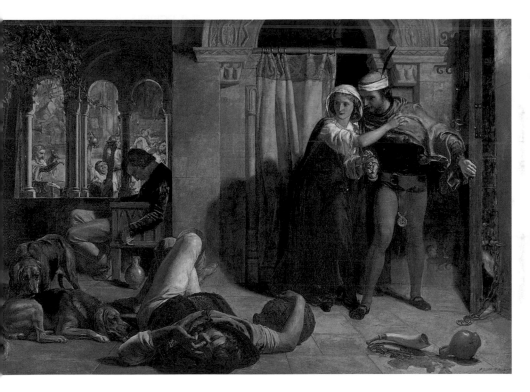

with more or less skill, in the same way as artists of other nationalities. Their dogs, horses, village politicians, which formed little kitchen, interior, and genre scenes were only interesting for a minute, and even then the artists did not handle them as well as the Dutch. Weak, muddy colours layered over bitumen, false and lacking in vitality, with shadows too dark and highlights too intense. Soft, hesitating outlines that were vague and generalising. And as the date of 1850 approached, Constable's words of 1821 resonated, "In thirty years English art will have ceased to exist."

The Girlhood of Mary Virgin

Dante Gabriel Rossetti, 1848-1849
Oil on canvas, 83.2 x 65.4 cm
Tate Britain, London

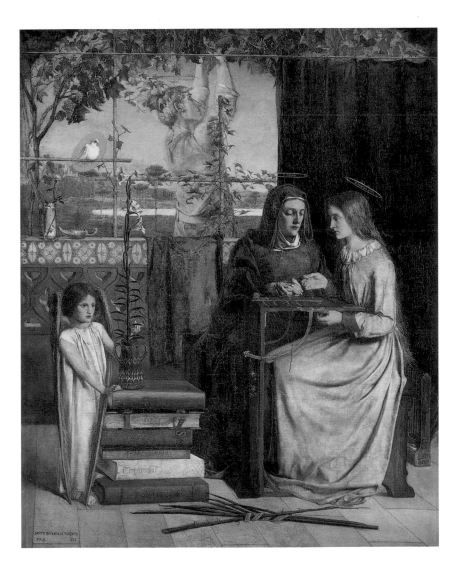

And yet, if we look closely, two characteristics were there, lying dormant. First, the intellectuality of the subject. The English had always chosen scenes that were interesting, even a bit complicated, where the mind had as much to experience as the eye, where curiosity was stimulated, the memory put into play, and laughter or tears provoked by a silent story. It was rapidly becoming an established idea (visible in Hogarth) that the paintbrush was made for writing, storytelling, and teaching, not simply for showing. However, prior to 1850 it merely spoke of the pettiness of daily life; it expressed faults,

The Renunciation of St Elizabeth of Hungary

James Collinson, c. 1848-1850
Oil on canvas, 120 x 182 cm
Johannesburg Art Gallery, Johannesburg

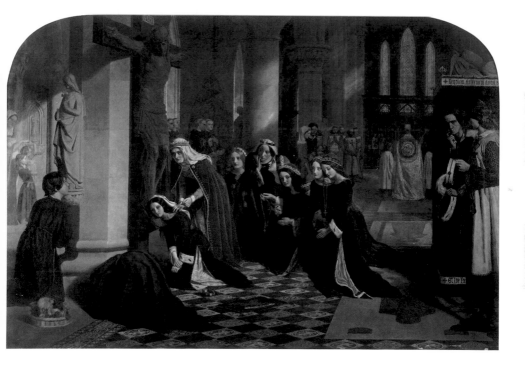

errors or rigid conventional feelings; it sought to portray a code of good behaviour. It played the same role as the books of images that were given to children to show them the outcomes of laziness, lying, and greed. The other quality was intensity of expression. Anyone who has seen Landseer's dogs, or even a few of those animal studies in English illustrated newspapers where the *habitus corporis* is followed so closely, the expression so well-studied, the look of the animal so intelligent and so different depending on whether it is waiting, feeling fear or desire, questioning its master, or thinking,

Rienzi vowing to obtain justice for the death of his young brother, slain in a skirmish between the Colonna and the Orsini factions

William Holman Hunt, 1849
Private collection

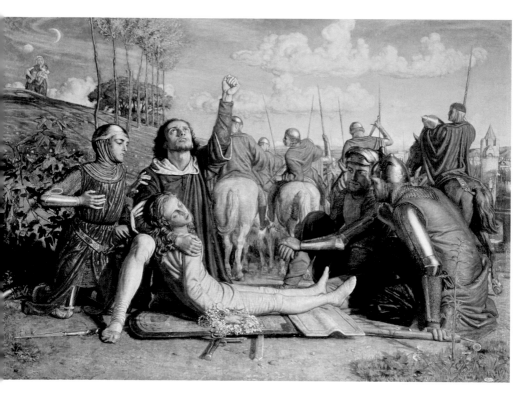

can easily understand what is meant by "intensity of expression". But in the same way that intellectuality was only present before 1850 in subjects that were not worth the effort, intensity of expression was only persistently sought and successfully attained in the representation of animal figures. Most human figures had a banal attitude, showing neither expressiveness nor accuracy, nor picturesque precision, and were placed on backgrounds imagined in the studio. They were prepared using academic formulas, according to general principles that were excellent in themselves, but poorly understood and lazily applied.

Christ in the House of his Parents
("The Carpenter's Shop")

John Everett Millais, 1849-1850
Oil on canvas, 86.4 x 139.7 cm
Tate Britain, London

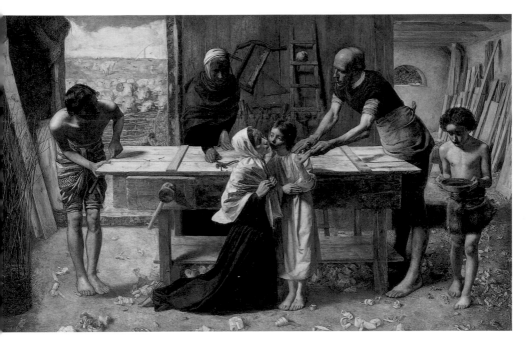

Such was English art until Ford Madox Brown came back from Antwerp and Paris, bringing an aesthetic revolution along with him. That is not to say that all the trends that have emerged and all the individuality that has developed since that time originated from this one artist, or that at the moment of his arrival, none of his compatriots were feeling or dreaming the same things that he was. But one must consider that in 1844, when *William the Conqueror* was exhibited for the first time, no trace of these new things had yet appeared. Rossetti was sixteen years old, Hunt seventeen, Millais fifteen, Watts twenty-six,

Ferdinand Lured by Ariel

John Everett Millais, 1849-1850
Oil on panel, 64.8 x 50.8 cm
The Makins Collection, Washington, D.C.

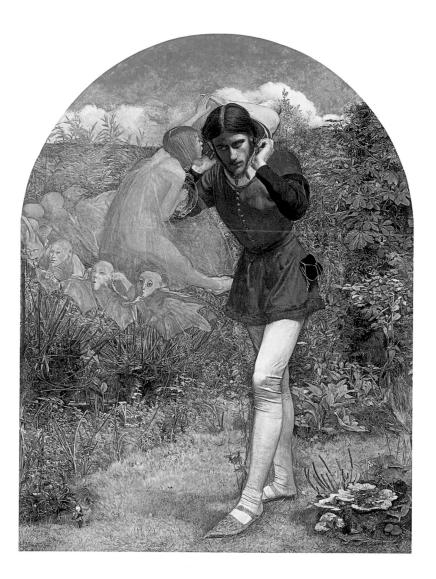

Leighton fourteen, and Burne-Jones eleven, and consequently not one of these future masters had finished his training. If one considers that the style of composition, outline, and painting ushered in by Madox Brown can be found fifty years after his first works in the paintings of Burne-Jones, having also appeared in those of Burne-Jones' master Rossetti, one must acknowledge that the exhibitor of 1844 played the decisive role of sower, whereas others only tilled the soil in preparation or harvested once the crop had arrived.

Ecce Ancilla Domini!
(The Annunciation)

Dante Gabriel Rossetti, 1849-1850
Oil on canvas, 72.4 x 41.9 cm
Tate Britain, London

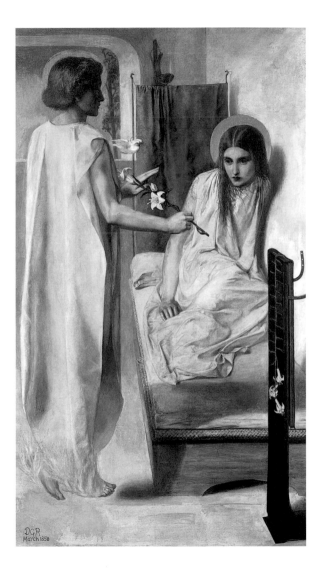

23

What, then, was in the hand of this sower? In his head was the idea that art was clearly perishing because of the systematic generalisation of forms, and could only be saved by the opposite, that is, the meticulous pursuit of individual traits. In his heart was the indistinct but burning desire to see art play a great social role in England. Finally, in his hand were a certain elegant awkwardness, a slightly stiff delicacy, and a meticulous attention to detail that he had learned partly from the Gothic school of Baron Wappers in Antwerp, and partly from direct observation of the Primitives.

Twelfth Night, Act II, Scene III

Walter Howell Deverell, 1850
Oil on canvas, 101.6 x 132.1 cm
Christie's images, The FORBES Magazine Collection, New York

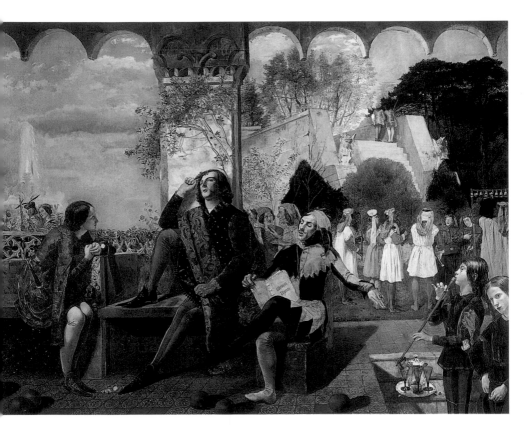

All of this was quite revolutionary, and for that reason must have displeased the conservative spirit of the English. But it was also anti-French, anti-continental, absolutely original and autonomous, so it must have appealed to their patriotism for these reasons. "It was in Paris that I decided to do realistic paintings, because no Frenchman was doing it," said Madox Brown.

When Madox Brown arrived in London, the great competition begun in 1843 for the decoration of the new Palace of Westminster was underway and had produced no less than 140 works signed by the best artists of the day.

A Converted British Family Sheltering a Christian Missionary from the Persecution of the Druids

William Holman Hunt, 1850
Oil on canvas mounted on panel, 111 x 141 cm
The Ashmolean Museum of Art and Archaeology,
University of Oxford, Oxford

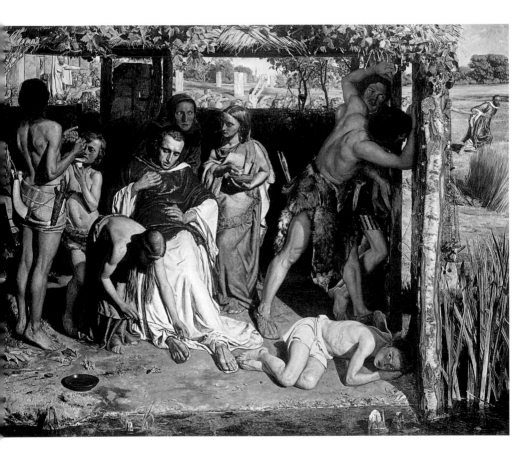

This aesthetic tournament is an important date in English art history, because it helped then unknown leaders to stand out from the crowd. Watts, a young artist who had learned independently, became noticed there. Madox Brown had sent five large compositions. The principal one was an episode from the Norman Conquest: *The Body of Harold brought to William the Conqueror.* These were his first forays down a new path, his protest against old and official art. His failure and the contempt of the public were so obvious that the day when the young master received a letter signed with an

Mrs James Wyatt Jr and her Daughter, Sarah

John Everett Millais, c. 1850
Oil on mahogany, 35.3 x 45.7 cm
Tate Britain, London

Italian name — Dante Gabriel Rossetti — in which the writer praised his work and asked to become his student, he had no doubt that this unknown man was mocking him. A few days later, he presented himself at Rossetti's home. "I was told," recalls the poet, "that a man was asking to see me. This man wanted neither to come in nor to give his name, and was waiting in the corridor. So I went down to see him, and when I arrived at the bottom of the stairs I found Brown holding a large stick in one hand and waving my letter about in the other. Instead of greeting me, he cried out: 'Is your name Rossetti and was it you who wrote this?'

Convent Thoughts

Charles Allston Collins, 1850-1851
Oil on canvas, 84 x 59 cm
The Ashmolean Museum of Art and Archaeology,
University of Oxford, Oxford

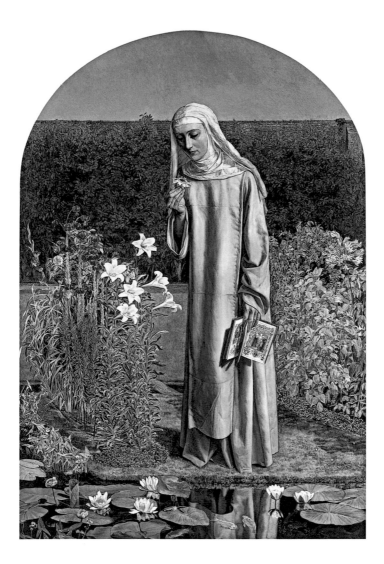

I responded in the affirmative, but I was shaking in my boots. 'What is the meaning of this letter?' he asked, and when I replied that I meant exactly what I had said, that I wanted to be a painter and had no idea what I should do to become one, Brown began to realise that the letter was not a mockery but a sincere homage, and he immediately changed from a mortal enemy into the gentlest of friends." This young man, who appeared so unexpectedly to join ranks with Madox Brown, was only twenty years old. He was the son of an Italian exile, born in the little town of Vastod'Ammone perched in the mountains of the Abruzzo region.

Two Gentlemen of Verona,
Valentine Rescuing Sylvia from Proteus

William Holman Hunt, 1851
Oil on canvas, 98.5 x 133.3 cm
Birmingham Museum and Art Gallery, Birmingham

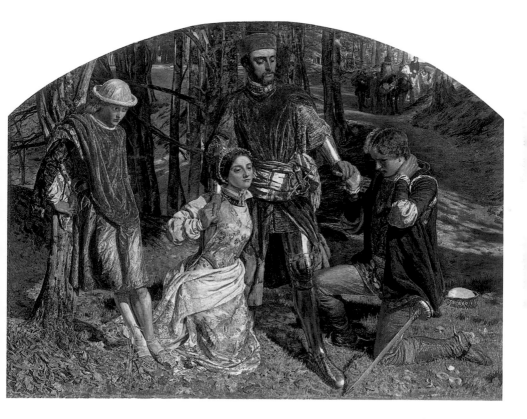

It was because his father, a highlander curious about civilisation, had gone down to Naples and worked for many years as a museum curator that the ideas of art and of great art had entered into his family. It was because this protector of the ancient gods was also a destroyer of modern monarchies, a poet known for his impetuous songs who so incriminated himself that in 1820 the return of the Bourbons saw him thrown onto English soil. And finally, it was because he married the sister of one of Byron's friends, the doctor Polidori, that his children could gather from the memories, passions,

The Hireling Shepherd

William Holman Hunt, 1851
Oil on canvas, 76.4 x 109.5 cm
Manchester Art Gallery, Manchester

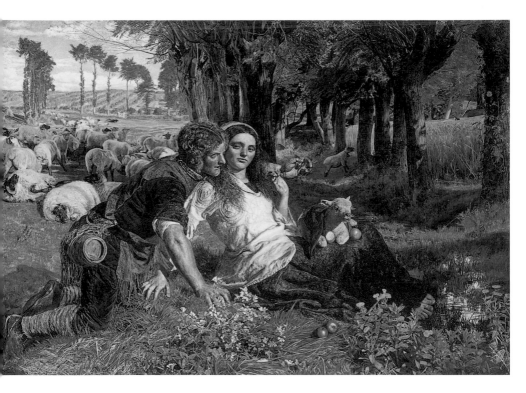

and grief of the family an echo of all the great patriotic pains that had unsettled the youth of that century. All of these events were perhaps necessary so that, in March 1848, the Gothic art of Madox Brown left some impression other than that of scandal or outmoded charm on an inhabitant of London. Madox Brown, thinking that the first priority was to force this fiery spirit to conform to the rigid discipline of reality, had the future creator of *Dante's Dream* work at copying tobacco boxes. Rossetti, who had gone through his academic courses without learning much, resigned himself to

The Bridesmaid

John Everett Millais, 1851
Oil on panel, 27.9 x 20.3 cm
The Fitzwilliam Museum, Cambridge

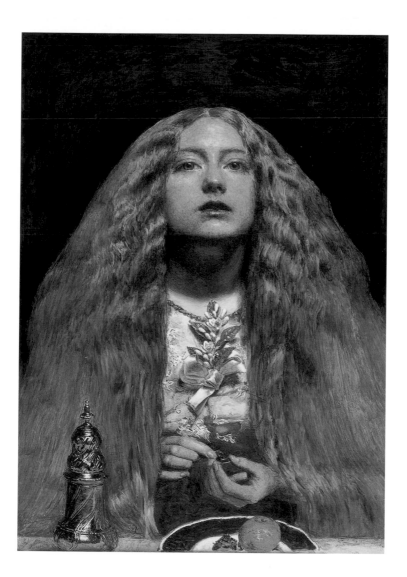

follow the advice that he had requested, for better or for worse. He worked impatiently, passionately, carelessly, and in disorder, cleaning his palette with bits of paper that he threw on the ground and that later stuck to the boots of visitors, starting twelve paintings at once, then falling into complete prostration, weary, disgusted with everything and with himself, finishing nothing, no longer wanting to listen to anyone, and rolling on the ground letting out awful moans. Then he disappeared for a month. Madox Brown was not angered, thinking that his student had heard some voices from the heavens calling him to other work.

Mariana

John Everett Millais, 1851
Oil on mahogany, 59.7 x 49.5 cm
Tate Britain, London

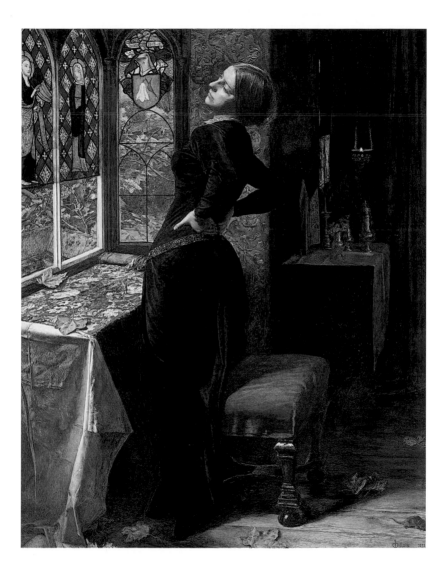

These voices were those of the "trecentists" (13th-century Italian poets) that he listened to in the libraries, as he was trying to create sonnets and poems. Gaunt and dark, with a foreign accent and appearance, a rounded forehead and gleaming eyes, his hair falling down to his shoulders, his beard cut in the style of a Neapolitan fisherman, careless in his dress, and covered with stains, he seemed infinitely superior to the young people studying painting at the Royal Academy. His passion for the picturesque side of things, his disdain for

Ophelia
—
John Everett Millais, 1851
Oil on canvas, 76 x 112 cm
Tate Britain, London

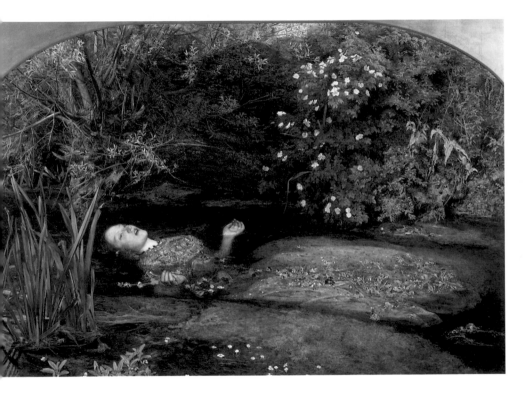

the discoveries of science, the continuous motion of his mind, and his mysticism crossed with a desire to sell his paintings at very high prices must have completely disconcerted even his close friends.

While Rossetti was copying tobacco boxes in Madox Brown's studio, one of his classmates at the Royal Academy was making desperate, superhuman efforts to create a place for himself as an independent artist and thus escape from a future in business. His name was William Holman Hunt, and he was twenty-one years of age. His father, a businessman with a small enterprise in the City,

The Return of the Dove to the Ark

John Everett Millais, 1851
Oil on canvas, 88.2 x 54.9 cm
The Ashmolean Museum of Art and Archaeology,
University of Oxford, Oxford

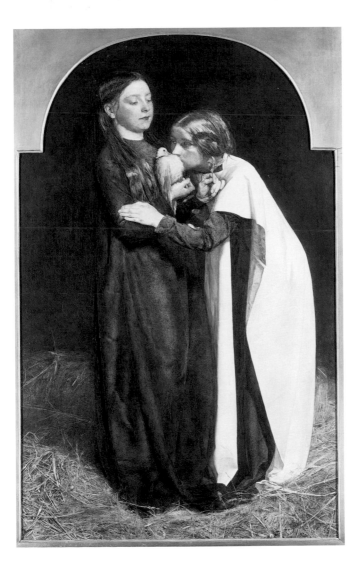

had tried everything to dissuade him from his artistic career. But never has fatherly prudence been so obstinately thwarted by destiny. At twelve years old the boy spent his time drawing instead of learning, so he was taken out of school and given a job as a clerk in an auctioneer's office. One day Hunt's new employer caught him hiding something in his desk and insisted on knowing what it was. He discovered that it was a drawing and was filled with joy. "It's good," he said. "On our first free day, we will shut ourselves in here and spend the day painting." This lasted for a year and a half, after which the young man was placed in a warehouse.

The Woodsman's Daughter

John Everett Millais, 1851
Oil on canvas, 84 x 65 cm
Guildhall Art Gallery,
Corporation of London, London

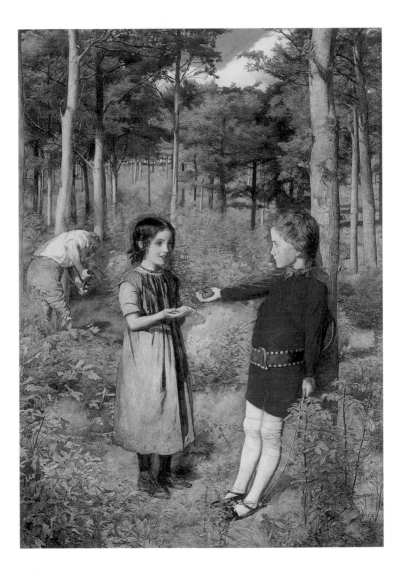

There he met another assistant whose principal task was to draw ornaments for the company's fabrics. Naturally, the young Hunt helped him with his task and dreamed more than ever of becoming an artist. Meanwhile, he spent his savings taking lessons from a portrait painter who was a student of Reynolds. One day, an old orange merchant came to his warehouse to offer her produce, and Hunt made such a lifelike portrait of her that word of it spread among all the neighbours and reached the ears of the elder Hunt. The son took advantage of these circumstances to declare that he would be a painter and nothing but,

Pretty Baa-Lambs

Ford Madox Brown, 1851-1859
Oil on panel, 60 x 75 cm
Birmingham Museum and Art Gallery, Birmingham

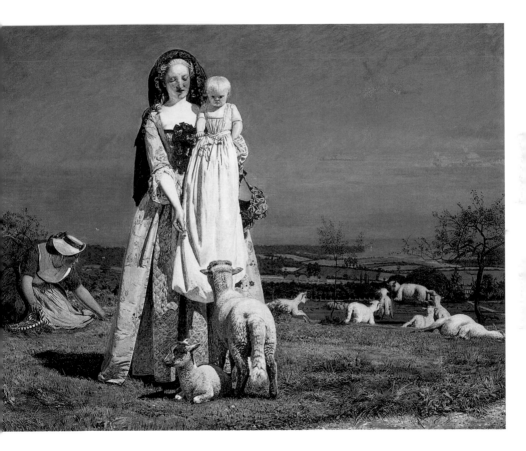

and the exhausted father gave in. For a long time, Holman Hunt struggled with poverty, engaging in various sorts of drudgery to try to escape it. He reproduced the paintings of the masters on behalf of other copyists and retouched portraits that no longer pleased their owners, either because they were not lifelike enough, or because they were too lifelike, or because the clothing in them had gone out of style. He failed the entrance examinations for the Royal Academy twice. After a thousand setbacks, threatened with returning to business or going to work in the countryside with his uncle, a farmer, he finally succeeded.

Ophelia

Arthur Hughes, 1852
Oil on canvas, 68.7 x 123.8 cm
Manchester Art Gallery, Manchester

There is a willow grows aslant the brook, That shows his hoar leaves in the glassy stream; There with fantastic garlands did she come, Of crow-flowers, nettles, daisies, and long purples. There on the pendant boughs her coronet weeds Clambering to hang, an envious sliver broke, When down the weedy trophies and herself Fell in the weeping brook.

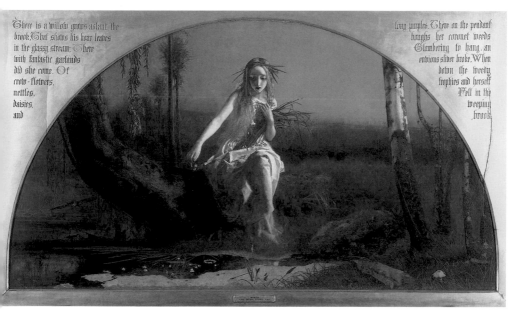

49

Fortunately, his career had a few good moments here and there. During his time at the Academy, Hunt met a young man two years younger than himself named John Everett Millais, practically a child, who surprised his masters with his marvellous talent. At fifteen, he had already won a medal for his studies of ancient art. Everything seemed to promise him a most brilliant career. The two young men often spoke about the future, about their own, but also about that of English art, which they found had aged poorly. They spoke of the heavy, dreary, blackish colours that they were taught to use in school,

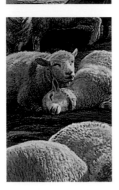

Our English Coasts, 1852
("Strayed Sheep")

William Holman Hunt, 1852
Oil on canvas, 43.2 x 58.4 cm
Tate Britain, London

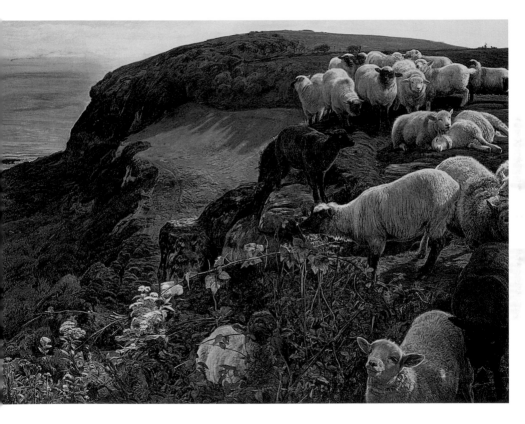

comparing them with the light, lively, musical hues used by the great masters of the past and found in nature. Hunt was struck by something a passerby had said to him while he was copying Wilkie's *Blind Fiddler* at the National Gallery: "You will never achieve the freshness of Wilkie if you paint over brown, grey, or bitumen. If you first cover the canvas with neutral colours, certain ones for the shadows and others for the light, like they teach you to do at the Academy, these backgrounds will eventually come out from under your colours and blacken them. Wilkie painted on a white canvas,

A Huguenot, on St Bartholomew's Day, Refusing to Shield Himself from Danger by Wearing the Roman Catholic Badge

John Everett Millais, 1852
Watercolour and pen and ink on paper, 13.3 x 8.7 cm
Cecil Higgins Art Gallery, Bedford

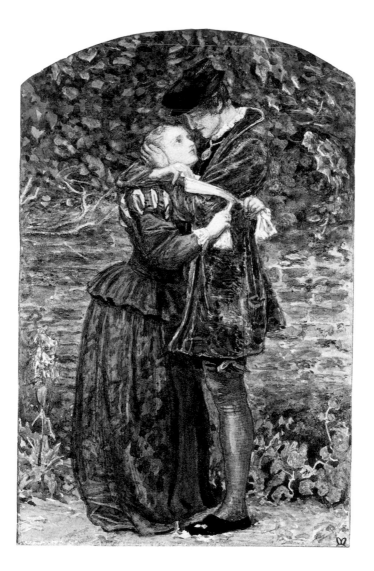

without a coloured ground, and finished his painting bit by bit like a fresco." Hunt and Millais both thought about it and, after examining the few Primitive paintings that they saw here and there in the galleries, they began wondering if their eternal freshness came from this straightforward working method, without underpainting and mixing tricks, that the masters before Raphael had imported from fresco painting, where it is unavoidable, into oil painting, where it was later abandoned.

Besides aesthetic discussions, Holman Hunt's other great pleasure was reading. One evening,

The Order of Release 1746

John Everett Millais, 1852-1853
Oil on canvas, 102.9 x 73.7 cm
Tate Britain, London

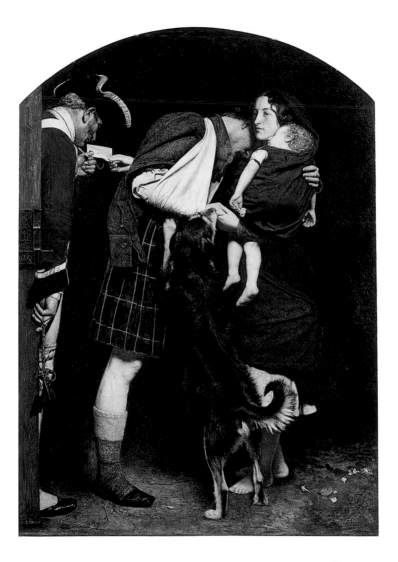

one of his studio companions brought him a book by an Oxford graduate that had only recently appeared but was constantly being reprinted: *The Modern Painters*. Holman Hunt leafed through the book, first with curiosity, then with admiration, and finally with enthusiasm. It was a swift plea, eloquent and passionate, in favour of naturalist landscapes and rejecting composed academic ones. It was a glittering study full of facts and examples where one sensed the experience of a practising artist behind each theory, a dissertation where one felt that every stroke of the pen had been preceded by a stroke of the brush. Hunt was captivated.

Jesus Washing Peter's Feet

Ford Madox Brown, 1852-1856
Oil on canvas, 116.8 x 133.3 cm
Tate Britain, London

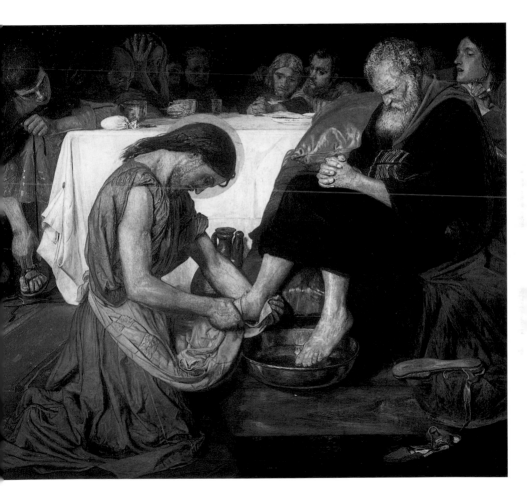

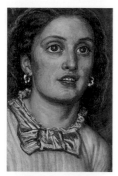

These pages were written by a stranger, but nonetheless seemed to have been created specifically for him, for they expressed so clearly the very things he felt vaguely in his soul. So he spent the night hunched over the book, reading.

The young painter read the book, hoping that he would find what he had been seeking for so long; a call to arms against academic generalisation and a superior model that could be opposed to the academic models. Finally, he came upon this page: "From young artists nothing ought to be tolerated but simple *bona fide* imitation of nature.

The Awakening Conscience

William Holman Hunt, 1853
Oil on canvas, 76.2 x 55.9 cm
Tate Britain, London

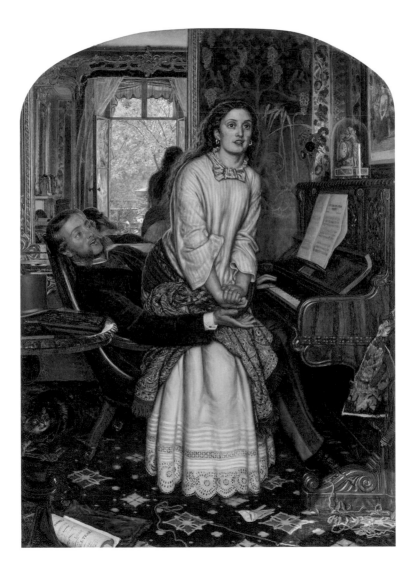

They have no business to ape the execution of masters to utter weak and disjointed repetitions of other men's words, and mimic the gestures of the preacher without understanding his meaning or sharing in his emotions. Their duty is neither to choose, nor compose, nor imagine, nor experimentalise, but to be humble and earnest in following the steps of nature, and tracing the finger of God. They should keep to quiet colours, greys, and browns and make the early works of Turner their example, as his latest are to be their object of emulation, should go to nature in all singleness of heart,

Portrait of John Ruskin

John Everett Millais, 1853-1854
Oil on canvas, 78.7 x 68 cm
The Ashmolean Museum of Art and Archaeology,
University of Oxford, Oxford

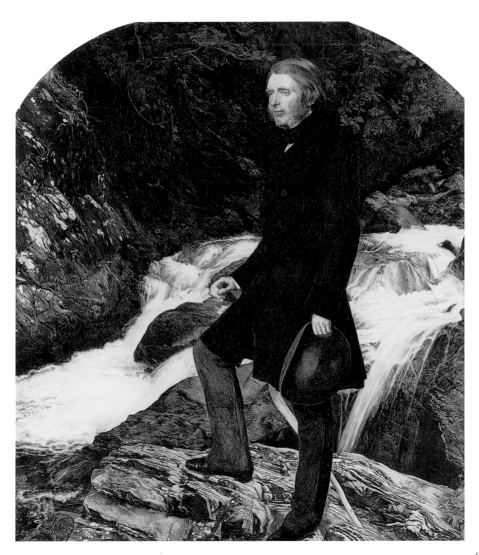

61

and walk with her laboriously and trustingly, having no other thoughts but how best to penetrate her meaning, and remember her instruction rejecting nothing, selecting nothing, and scorning nothing; believing all things to be right and good, and rejoicing always in the truth." The call to arms had been found.

Who, then, was the writer who, on this page written in 1843, gave the precise formula for realism well before the realists, at the time when Courbet and those like him were still children or barely out of school, were still struggling to find their way?

The Scapegoat

William Holman Hunt, 1854-1855
Oil on canvas, 87 x 139.8 cm
Lady Lever Art Gallery, Port Sunlight

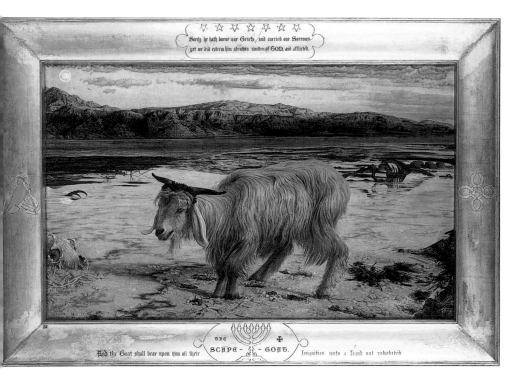

He, too, was almost a child. He had written this book when he was but twenty-three years old in a small house in Herne Hill, in the Surrey hills outside London. He had spent several years travelling with his parents in Italy and along the banks of the Rhine in Switzerland, amassing documents, copying paintings, studying leaves and flowers under a microscope, running through the museums and mountains with pencil in hand, sketching the mouldings of a cornice or the grand lines of a glacier. Then, determined to express his admiration for Turner and praise this great artist,

Jerusalem and the Valley of Jehoshaphat
from the Hill of Evil Counsel
───────────────────────

Thomas B. Seddon, 1854-1855
Oil on canvas, 67.3 x 83.2 cm
Tate Britain, London

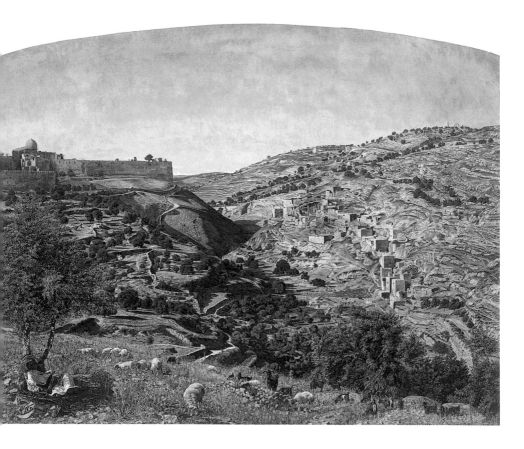

he made use of all of his observations and all these examples, and cried out to a stupefied England that nothing in the world was more beautiful than nature and art. The product of all this was the first volume of *Modern Painters*. John Ruskin (for it was he) delighted the English imagination for forty years with his appreciation of the heavens, clouds, woods, waters, and rocks, and raised his country progressively to his level of enthusiasm, whose very sincere expression was aestheticism. Understanding from the outset that his compatriots would not understand if he spoke to them of nature and art only in terms of beauty,

Lady Clare

Elizabeth Siddal, c. 1854-1857
Watercolour, 33.8 x 25.4 cm
Location unknown

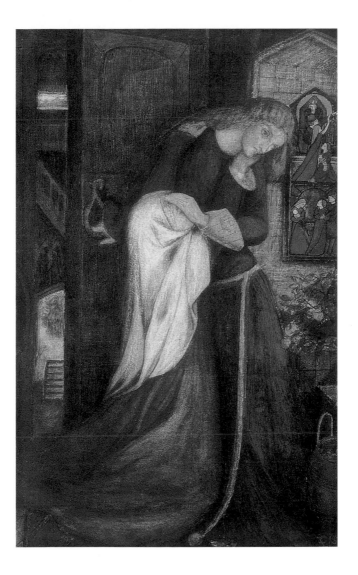

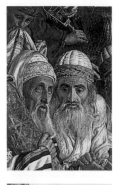

he spoke to them of truth and goodness, of usefulness, morals, biblical thought, and the curiosities of science. He was by turns a scholar, a historian, an anti-papist, an economic moralist, a poet, a botanist, and a geologist, and through his charming and learned discourse he attracted even the most resistant Englishmen to the idea of beauty. All of the winding paths in his historical promenade brought them inevitably to the same point, which was the social mission of art and its supremacy over all other things. At the time when the young

The Finding of the Saviour in the Temple

William Holman Hunt, 1854-1865
Oil on canvas, 85.7 x 141 cm
Birmingham Museum and Art Gallery, Birmingham

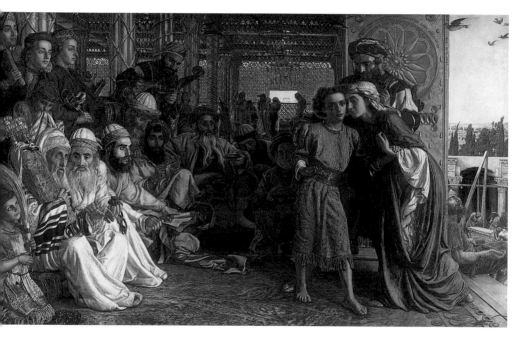

Hunt read his first work, John Ruskin was not yet a universally-known author whose books were reproduced by the million, but his keen words already carried authority. However, this authority was only honorary; he was listened to but not followed. To create a revolution in painting, even the most eloquent criticism is not sufficient: one needs painters to do the job. John Ruskin did not find them close to him and scanned the horizon to no avail, wondering if a few new men might appear whom he could make into his disciples.

The Last of England

Ford Madox Brown, 1855
Oil on panel, 82.5 x 75 cm
Birmingham Museum and Art Gallery, Birmingham

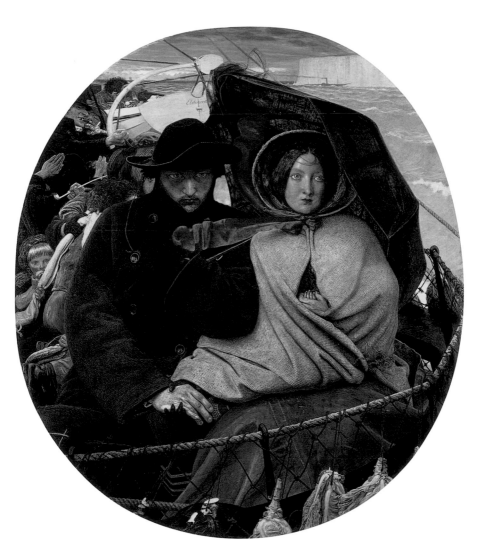

THE PRE-RAPHAELITE BATTLE

This was the state of affairs in England when, one evening in the year 1848, three young painters who worked in the same studio were taking tea at the home of the most wealthy among them. One was of Italian origin and the other two were English, and they were friends in the same way as sailors who set sail together and depend upon one another for help. They were thumbing through a collection of engravings by Campo Santo de Pise that lay on the table. All three of them were weary of the banalities of their school and had been searching

A Study, in March

John William Inchbold, 1855
Oil on canvas, 53 x 35 cm
The Ashmolean Museum of Art and Archaeology,
University of Oxford, Oxford

for several years for a master to whom they could devote themselves in order to escape from general movements, stereotyped poses, and expressions traced from the classics, each new tracing diluting the primitive beauty of the original. These frescoes by Campo Santo were a revelation.

The young men spoke of simple, individual, conscientious art employing neither formulae nor studio practices: the art of Benozzo Gozzoli and of Orcagna. "In this art, there is only the most meticulous, thorough imitation of nature possible, and the naive expression of religious ideas. Look at the expression of this horse! And see how this

The Bluidie Tryst

Joseph Noel Paton, 1855
Oil on canvas, 73 x 65 cm
Kelvingrove Art Gallery and Museum, Glasgow

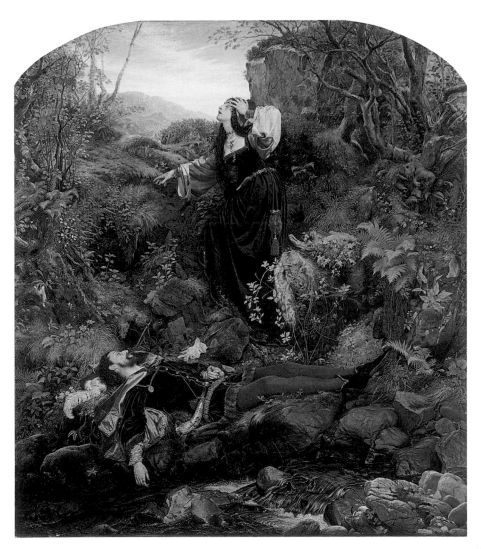

hermit prays with all his heart! And what colour should all this be? It should have the colours of van Eyck's work, fresh and brilliant! Colours applied directly to a white canvas... What has made art banal is that there is no longer this direct pursuit of nature. And it was lost quite a while ago! Rubens had already lost it, as had Carrache... even Jules Romain, even Raphael had lost it! To find masters that we can follow fearlessly, we will need to look to the period before Raphael, 'Pre-Raphaelite' art." The night carried on, and teacups were emptied one after the other. When the last one was finished, Pre-Raphaelitism had been born.

Dante's Vision of Rachel and Leah

Dante Gabriel Rossetti, 1855
Watercolour on paper, 35.2 x 31.4 cm
Tate Gallery, London

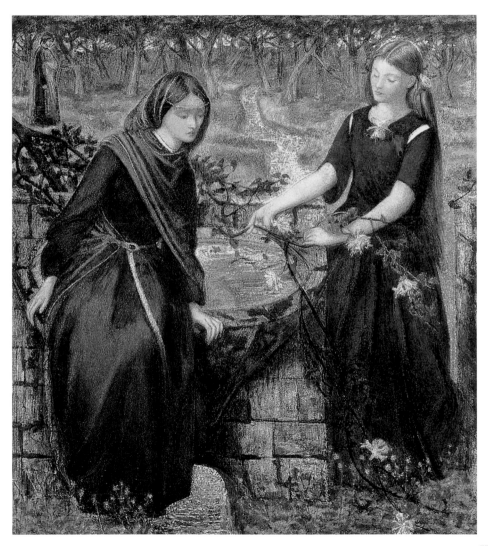

These three friends were Dante Gabriel Rossetti, William Holman Hunt, and John Everett Millais. All three of them had great natural abilities and a furious desire to succeed, and this trio made a perfect whole. Hunt had faith, Rossetti eloquence, and Millais talent. The Italian was more poetic, Millais was more of a painter, and Hunt was more Christian. Rossetti, anxious and agitated, needed to prophesy something, anything, to anyone who came along. The conscientious Hunt needed to believe in something and devote himself to a great cause. The practical and ambitious Millais needed a theory to set him apart from the crowd of skilful

The Hayfield
———————
Ford Madox Brown, 1855-1856
Oil on panel, 24.1 x 33.3 cm
Tate Britain, London

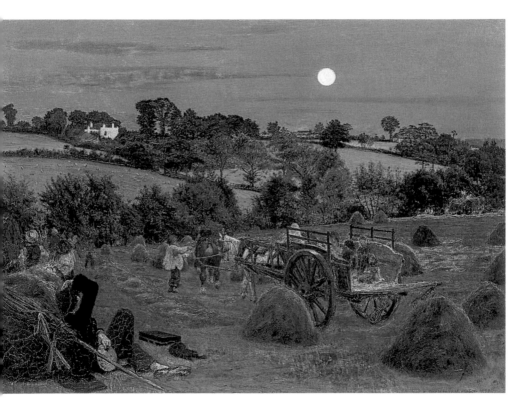

painters and was unconcerned with believing or prophesying. They set to work. Rossetti recruited adepts somewhat randomly, Hunt took great pains to conform to the precepts of the cult, and Millais reaped the applause. Seeing the leader, people said "How well he speaks!" Observing the disciple, they said "How devoted he is!" and seeing their friend, "He makes such beautiful things!" Only after many long years did it become apparent that the disciple did not do what he was told, and that their friend was successful only because he did not listen to the leader or imitate the disciple.

Glacier of Rosenlaui

John Brett, 1856
Oil on canvas, 44.5 x 41.9 cm
Tate Britain, London

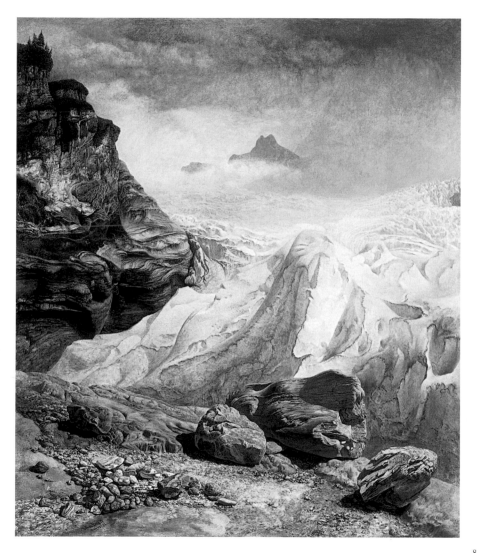

In France, these revolutionaries would have been content with supporting the same ideals and going to the same café for meetings. But in England, where three admirers of Shakespeare or Browning could not meet without forming a Shakespeare Reading Society or a Browning Discussion Group, the Pre-Raphaelites created a Brotherhood. And, as all Englishmen have a pronounced taste for following their names with a few different letters, with three or four specimens from the alphabet, they decided that each Pre-Raphaelite Brotherhood would include the initials of his new title, P.R.B, in his signature. They included them in the addresses of their letters when

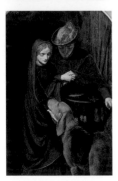

The Eve of St Agnes

Arthur Hughes, 1856
Oil on canvas, 71 x 124.5 cm
Tate Gallery, London

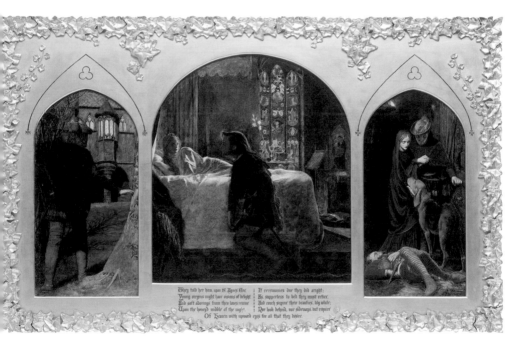

They told her how, upon St. Agnes' Eve
Young virgins might have visions of delight,
And soft adorings from their loves receive
Upon the honey'd middle of the night,
If ceremonies due they did aright;
As, supperless to bed they must retire,
And couch supine their beauties, lily white;
Nor look behind, nor sideways, but require
Of Heaven with upward eyes for all that they desire.

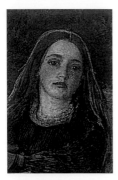

writing to one another, but this sign of brotherhood was most important on their works. Seven of the young painters of the day had the right to call themselves P.R.B. Three talented men, even ones as gifted as Hunt, Millais, and Rossetti, cannot make as much noise as one hundred mediocre ones, and they accepted four other Pre-Raphaelite brothers: Michael William Rossetti, who did not paint; Woolner, who did not paint either, but sculpted sometimes; Stephens, who ended up confining himself entirely to literature; and Collinson, who after having tried in vain to paint Elisabeth of Hungary,

Autumn Leaves

John Everett Millais, 1856
Oil on canvas, 104.3 x 74 cm
Manchester Art Gallery, Manchester

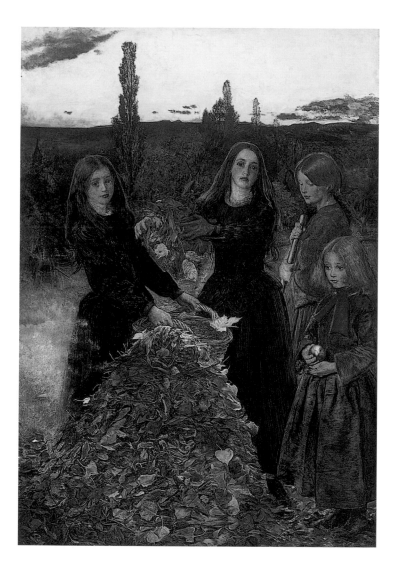

converted to Catholicism and entered a seminary. Later, the absent and hopeless members were replaced by three newcomers: Deverell, Hughes, and Collins, but these were only helpers. They escorted the trio of founders, gathering and rousing the crowd around them, writing articles, attracting attention, and ensuring that the group was noticed. It was Rossetti, Hunt, and Millais who had challenged official art. It was they who had to wage the battle and, given their limited resources, either emerge victorious or disappear.

The battlefield that they chose was the illustration of Keats' famous poem *Isabella; or, the Pot of Basil.*

The Blind Girl

John Everett Millais, 1856
Oil on canvas, 80.8 x 53.4 cm
Birmingham Museum and Art Gallery, Birmingham

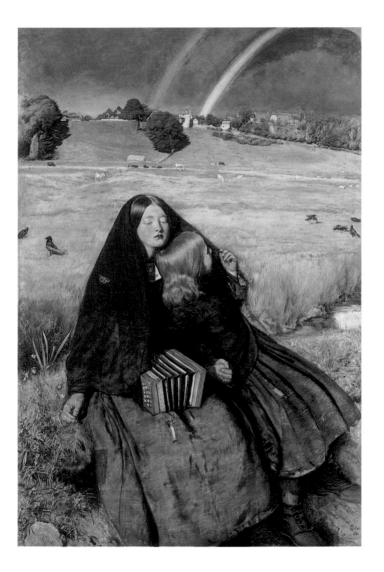

This mournful story, based on Boccaccio, is well known: "Fair Isabel, poor simple Isabel" was the sister of two rich Florentine merchants. In their house, under their command, was the young Lorenzo, who – like all heroes – was quite handsome. The young man and the young woman "could not in the self-same mansion dwell, without some stir of heart, some malady. They could not sit at meals but feel how well it soothed each to be the other by. They could not, sure, beneath the same roof sleep, but to each other dream, and nightly weep." Isabel's brothers quickly noticed the drama that was unfolding before their eyes.

A Dream of the Past: Sir Isumbras at the Ford

John Everett Millais, 1857
Oil on canvas, 124 x 170 cm
Lady Lever Art Gallery, Port Sunlight

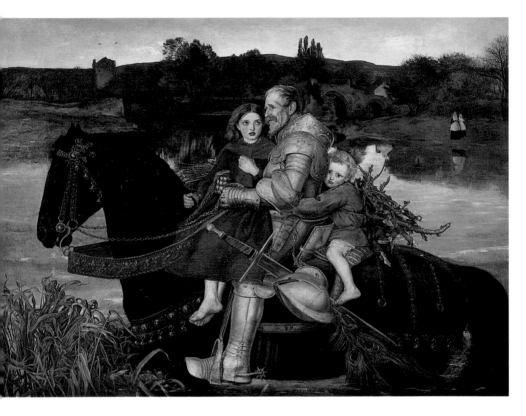

As they wished to marry their sister to some great lord, they resolved to murder Lorenzo. One fine morning, they asked him to go hunting near the Apennines. They hurried off, passed the Arno, and in a neighbouring forest, killed Lorenzo and buried him deep in the earth.

Upon their return, they explained that the young man had set sail quickly for a foreign country because of some pressing need. Isabel asked them if he would return soon, but got no reply, and they deceived her every day with new stories. Finally, she had a dream that revealed the truth to her. In it appeared Lorenzo, who said to her: "Isabel, my sweet!

Hesperus

Sir Joseph Noel Paton, 1857
Oil on canvas, 91 x 69 cm
Kelvingrove Art Gallery and Museum, Glasgow

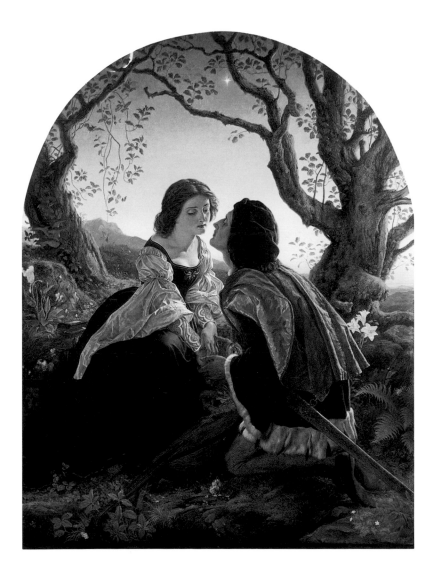

Red whortleberries droop above my head, and a large flint-stone weighs upon my feet. Around me beeches and high chestnuts shed their leaves and prickly nuts." When morning came, she ran to the forest with her old nurse. Her eyes fell upon the knife that had been used in the murder. The two women dug and dug, and found the corpse. Then, the distraught lover, wanting to keep something of the dead man at any price, cut off his head and carried it back home with her. There she embalmed it and hid it in a flowerpot, under a basil plant that was kept green by her endless tears. Day and night, she cried over the plant, which grew and flowered wondrously.

The Tune of the Seven Towers

Dante Gabriel Rossetti, 1857
Watercolour on paper, 31.4 x 36.5 cm
Tate Britain, London

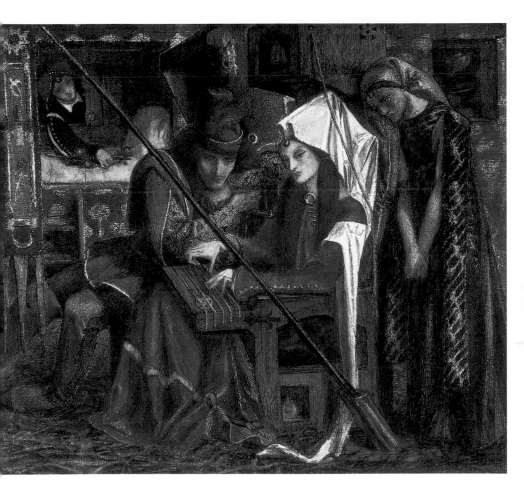

This astonished her brothers, who looked to see what was under the basil, and though "the thing was vile with green and livid spot", they recognised Lorenzo's head. Appalled, they fled their homeland, carrying away what remained of their victim. But as soon as she no longer had her beloved plant, Isabel fell ill and wasted away. And finally she died, mournfully asking everyone else who approached her and pilgrims returning from faraway lands, what had become of her basil-pot.

This was the drama from which each of the Pre-Raphaelites was expected to depict a scene, rigorously applying the theories of their new school:

The Wedding of St George and Princess Sabra

Dante Gabriel Rossetti, 1857
Watercolour on paper, 36.5 x 36.5 cm
Tate Britain, London

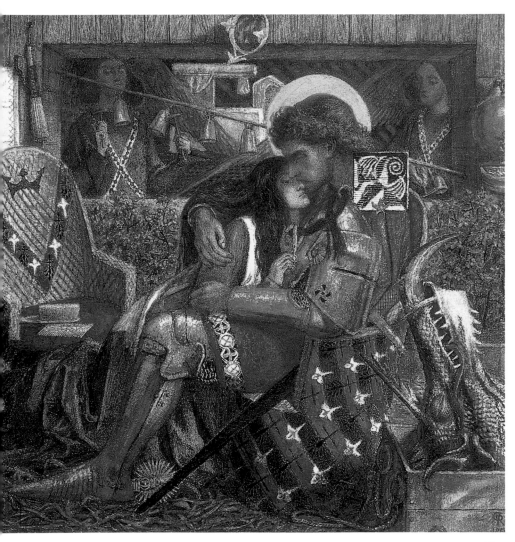

no imitation of the masters, no generalisation, each figure reproduced from a model and from one single model, outlines as original and individual as possible, painting on an unprepared white canvas, and fastidious attention to detail. In a word, earnestness. But, while Rossetti continued talking away and Hunt prepared by meticulously studying every detail of his subject, Millais had already constructed, sketched out, and finished his painting. For the Exhibition of 1849, in which all three of them participated together, only Millais produced a work inspired by Keats.

The Stonebreaker

John Brett, 1857-1858
Oil on canvas, 51.3 x 68.5 cm
Walker Art Gallery, Liverpool

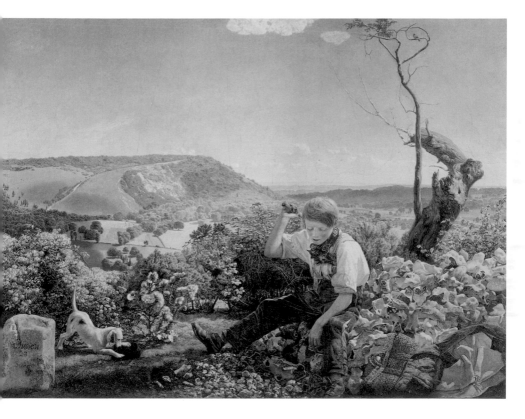

This work depicts Isabella and Lorenzo seated together at the table, where he is offering her half an orange on a plate. Across from them, on the other side of the table, the two brothers, one cracking a nut and the other lifting his glass to his lips, cast suspicious glances toward the couple. At the same time, Hunt exhibited *Rienzi swearing Revenge over his Brother's Corpse*. A fight had just taken place between several nobles over the division of Rome. We see the young Rienzi dead, stretched out on a shield, and his eldest brother is raising his fist to the sky. The third P.R.B., Rossetti, exhibited a painting depicting *The Girlhood of Mary Virgin*,

The Annunciation

Arthur Hughes, 1857-1858
Oil on canvas, 61.5 x 35.8 cm
Birmingham Museum and Art Gallery, Birmingham

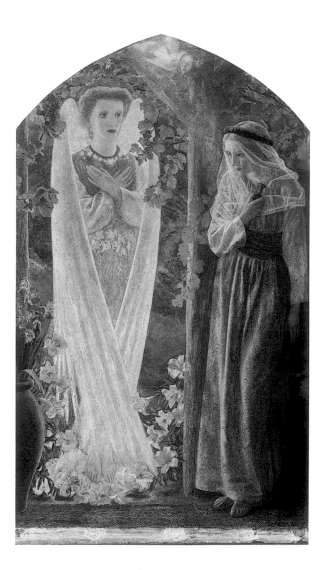

not at the Academy, but at the Chinese Gallery in Hyde Park where his master, Madox Brown, had also sent his famous painting of *Cordelia's Portion,* a scene taken from *King Lear.* Thus, in the spring of 1849 the three P.R.B. and the man who inspired them made their first collective attempt at a new art.

The paintings by Hunt and Millais were hung in prominent places, and the painters were congratulated by many of the people in attendance on the morning of the private view. Their realism did not shock the audience at all, *The Times* was benevolent, and the professors of the Royal Academy were moderate in their criticism.

Vale of Aosta

John Brett, 1858
Oil on canvas, 88 x 68 cm
Private collection

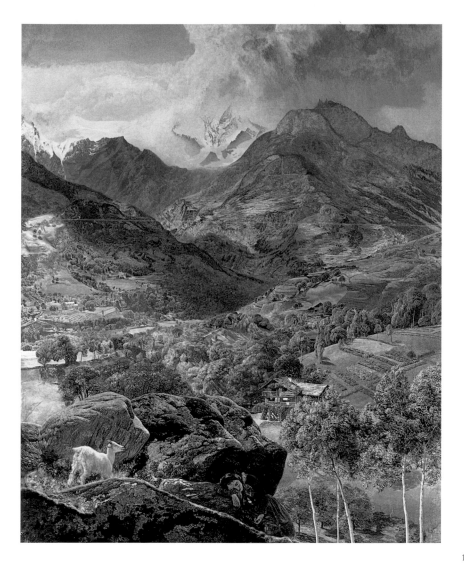

No one had noticed the mysterious letters P.R.B on Isabel's chair, a visible sign of the conspiracy. The Pre-Raphaelites found buyers immediately, which is a sign of predestination in England as it is elsewhere. They prepared for the Exhibition of 1850, and after a short trip to France, galvanised by their success, they created a magazine called *The Germ,* in which the Pre-Raphaelite thesis was presented and developed, revealing the meaning of the letters P.R.B. The friends of these innovators gave, in each issue of *The Germ*, published from January to April of 1850, the secret of their preferences,

La Belle Iseult

William Morris, 1858
Oil on canvas, 71.8 x 50.2 cm
Tate Gallery, London

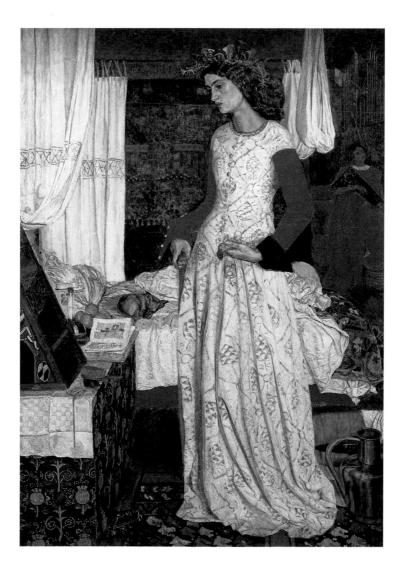

their antipathies, and their ambitions. This revelation caused a sudden turn of events. The idea that the Pre-Raphaelites wanted to change something in the aesthetic constitution of their country deeply upset the same people that their works had not shocked at all. English conservativism let out a cry of terror. These events coincided with the 1850 Exhibition, where Millais presented his *Christ in the House of his Parents,* Hunt *The Missionary,* and Rossetti *The Annunciation.* The entire press thundered against them. The great Charles Dickens himself entered the arena and wrote a vigorous diatribe against Millais' painting, which depicted the baby

Before the Battle

Dante Gabriel Rossetti, 1858 retouched in 1862
Transparent and opaque watercolour on paper,
mounted on canvas, 41.4 x 27.5 cm
Museum of Fine Arts, Boston

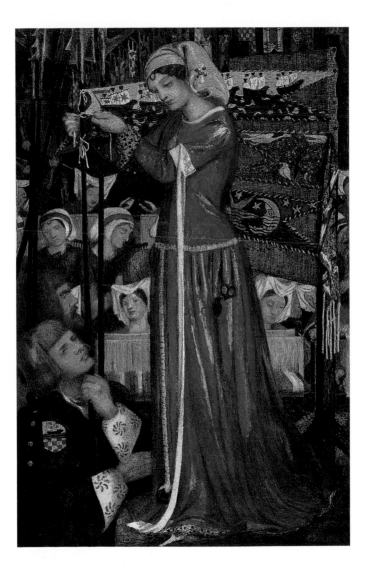

Jesus in his father's workshop. Jesus has just hurt himself with some pliers, and the kneeling Virgin is embracing and consoling him; Saint Joseph is holding his hand. A young Saint John the Baptist is bringing water to dress his wound. Saint Anne is removing the pliers, which are still on the table. An apprentice is adjusting a plank, continuing his work uninterrupted. Here was a new and curiously realistic expression of the dreadful prophecy: "And one shall say unto him, What are these wounds in thine hands? Then he shall answer, Those with which I was wounded in the house of my friends." Dickens wrote: "As you approach the Holy Family of Millais,

The Long Engagement

Arthur Hughes, 1859
Oil on canvas, 107 x 53.3 cm
Birmingham Museum and Art Gallery, Birmingham

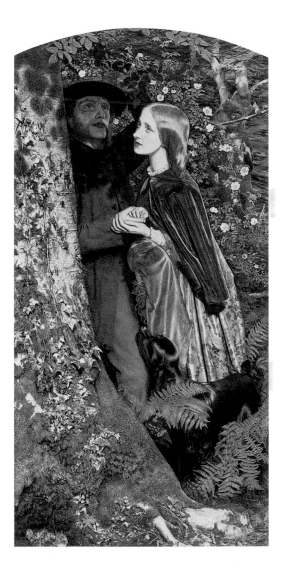

you must drive out of your head any religious conception, any elevated thought, any connection with the tender, dramatic, sad, noble, sacred, dear, and beautiful, and prepare to lower yourself to the bottom of all this horrible, shameful, repulsive, and infuriating." The P.R.B. could not even plead against this terrible verdict with an article in *The Germ*, which had been defunct since April for lack of funds. William Rossetti protested in *The Spectator*, but what use was a single voice against this tempest? The purchases stopped and the purses of art collectors snapped shut in indignation. For an entire year, the struggle continued. The P.R.B.

Sir Galahad at the Ruined Chapel

Dante Gabriel Rossetti, 1859
Watercolour on paper, 29.3 x 33.9 cm
Birmingham Museum and Art Gallery, Birmingham

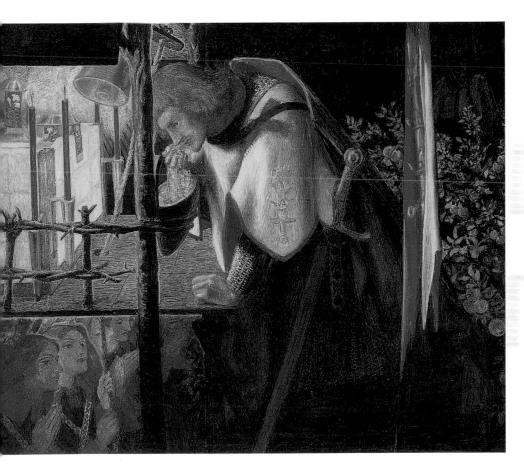

109

persevered and participated in the Exhibition of 1851, but the slander against them knew no bounds. Millais' *Mariana* was disparaged and Holman Hunt's *Valentine and Sylvia* was especially showered with insults. Some went as far as to ask that the Pre-Raphaelite paintings be removed from the walls of the Academy before the end of the Exhibition. Now it was proved beyond a doubt that they offended the audience. Madox Brown, who had not wanted to be an integral part of the Brotherhood but who was interested in it, was filled with desperation at seeing his hopes vanish and his followers ruined.

Walton-on-the-Naze

Ford Madox Brown, 1860
Oil on canvas, 84 x 174.2 cm
Birmingham Museum and Art Gallery, Birmingham

It seemed that Pre-Raphaelitism was lost. With his warm heart, combative spirit, and diverse and brilliant intelligence, John Ruskin could not see such an unequal struggle without feeling indignation and seeing an opportunity for a blazing battle, in which he would fight single-handedly against everyone, armed with the marvellous weapons that nature and his studies had put into his hands. He did not know the P.R.B., but it did not take long for him to disentangle their disorderly cries and discover something that resembled his own words, and he glimpsed in their flawed essays the talent that they promised for the future.

The Wedding Banquet of Sir Degrevaunt

Edward Burne-Jones, 1860
One of three murals for the Red House reception hall
Victoria and Albert Museum, London

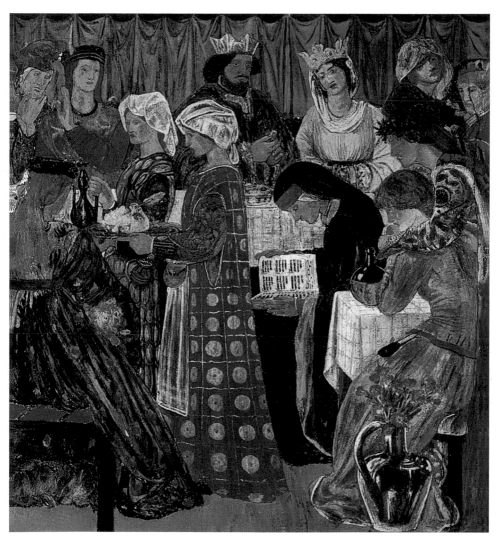

These were perhaps the followers that he had dreamed of. So, in his two memorable addresses to *The Times,* John Ruskin took hold of the official criticism and shook it roughly. The P.R.B. had been reproached for their perspective. Ruskin declared that he could find worse errors of perspective in any architectural painting by any fashionable painter that one would care to mention. The Brotherhood's fastidious attention to detail had been criticised, but Ruskin established it as one of their strong points, showing that merely from a botanical point of view,

The Knight of the Sun

Arthur Hughes, c. 1860
Oil on canvas, 101.6 x 132 cm
Private collection

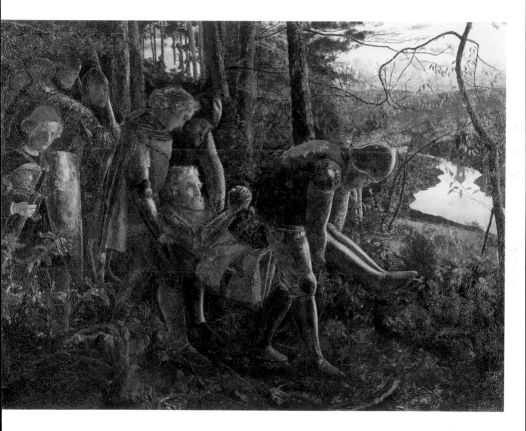

115

the water lily and the *alismaplantago* included in one of their paintings were invaluable, and that it would be impossible to find something worth as much as this part of Hunt's work in terms of truth, energy, and finishing in academic painting. It had been proclaimed that the P.R.B.'s works were lacking in effect, that is to say that there were not large areas of shadow which brought out the highlights. This was, for any artist, an important point in the debate. Ruskin, with his sure eye trained through the direct study of nature, spotted everything creative

Dantis Amor

Dante Gabriel Rossetti, 1860
Oil on mahogany, 74.9 x 81.3 cm
Tate Gallery, London

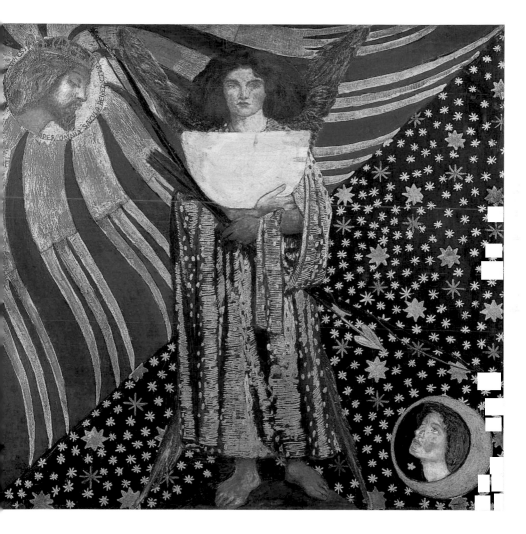

117

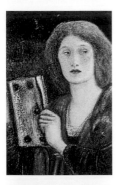

in the Pre-Raphaelite endeavour and hailed it immediately. Just as his praise for Turner in 1843 had led him, by a circuitous route, to give the exact formula of realism, the necessity of defending the P.R.B. led him on this day, 26 May 1851, to give the exact formula for *plein air* some thirty years before the Impressionists: "The apparent lack of shadows," he said, "is perhaps the fault which stands out the most. But if there is indeed a fault, it is not so much in the Pre-Raphaelite paintings than in those they are being compared with. It is the others that are in error, not the Pre-Raphaelites, disregarding the fact

Merlin and Nimue

Edward Burne-Jones, 1861
Watercolour and gouache, 64.1 x 52.1 cm
Victoria and Albert Museum, London

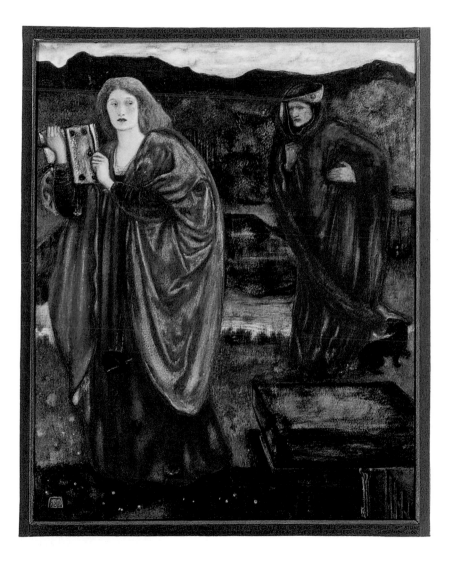

that all painting is false, in that it wishes to represent a living ray of light with inert colours. Finally, after having cleared these innovators of the accusation of Romanism, which was in those days a dreadful epithet across the Channel, Ruskin declared with his usual imperative confidence that in England, the Pre-Raphaelites had laid "the foundation of a school of art nobler than the world has seen for 300 years." This furious attack against the Academy confused public opinion. The exchange of blows slowed, and the Liverpool Academy dared to take the lead.

The Lady of Shalott

Walter Crane, 1862
Oil on canvas, 24.1 x 29.2 cm
Yale Center for British Art, New Haven

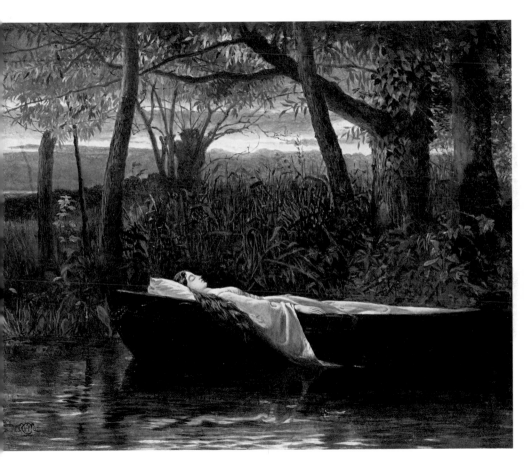

It awarded a prize to Hunt's *Valentine and Sylvia*, and the press coverage generated by the event convinced a Belfast collector to buy the painting without even having seen it. Pre-Raphaelitism had been saved.

Thus began a period which, though not yet one of triumph, was at least no longer one of persecution. Each year, the Liverpool Academy awarded its prize to one of the P.R.B. brethren. Ruskin generously bought watercolours from Rossetti. Millais, Hunt, and Collins, the brother of Wilkie Collins, spent a summer in Surrey to study nature for the backgrounds of

St George and the Princess Sabra

Dante Gabriel Rossetti, 1862
Watercolour on paper, 52.4 x 30.8 cm
Tate Gallery, London

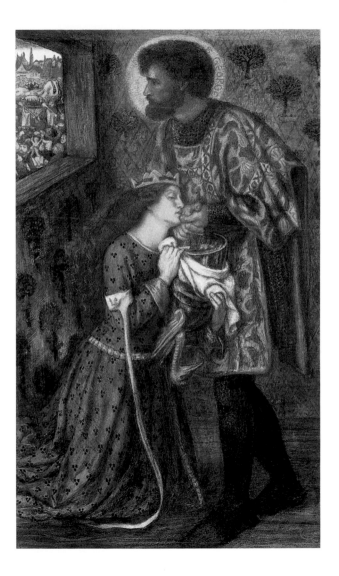

their next paintings. There, in the silence and calm of the countryside, they prepared works that will be forever celebrated. These were Millais's *Ophelia* and *A Huguenot* and Hunt's *Hireling Shepherd* and *Light of the World*. Millais wanted to paint his Ophelia floating in the river, her face turned toward the sky, her hands half-extended at the surface of the water, opened as if giving a blessing, her body half-stuck in grasses, dead willow leaves, nettles, daisies, and buttercups, her dress and draperies ballooning, slowly losing the lightness that had suspended them at the surface,

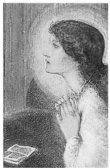

The Annunciation. The Flower of God

Edward Burne-Jones, 1863
Watercolour and gouache, 61 x 55.3 cm
Lloyd Webber Collection, London

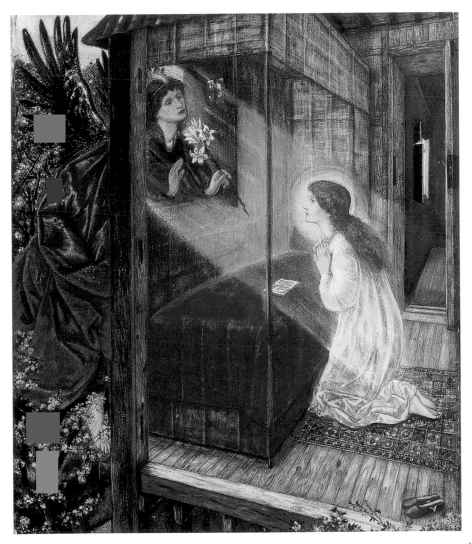

everything that had been the young woman disappearing beneath the low foliage and the straight reeds, slowly flowing away with the water towards some great river and towards death. Each leaf of the tree that he copied, each verse of the poet whose words inspired him, caused Millais an infinite number of difficulties, for he wanted to remain faithful to both nature and Shakespeare. Beside him, Hunt completed the background of his *Hireling Shepherd* and began that of his *Light of the World*.

The Merciful Knight

Edward Burne-Jones, 1863
Watercolour, 101.4 x 58.6 cm
Birmingham Museum and Art Gallery, Birmingham

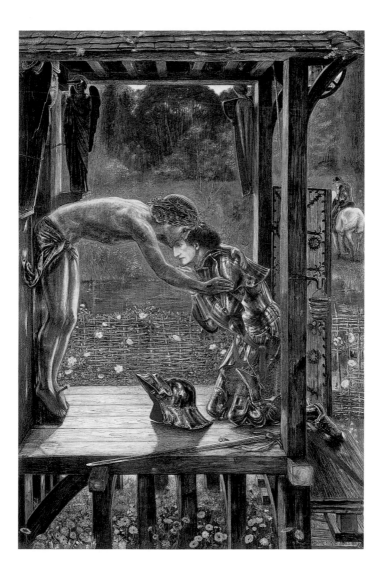

When the two friends returned to London, they found benevolent, smiling faces and open arms. The hour of their success was approaching, and it came first to Millais at the 1852 Exhibition. His *Ophelia* and *A Huguenot,* though they were still attacked by a few critics, won over the rest of the crowd. Reproductions spread throughout England. One year later, he was elected an Associate Member of the Royal Academy. Next, Holman Hunt also triumphed with his *Light of the World.* The most elegant ladies came to visit his studio

Home from Sea

Arthur Hughes, 1863
Oil on panel, 50 x 65 cm
The Ashmolean Museum of Art and Archaeology,
University of Oxford, Oxford

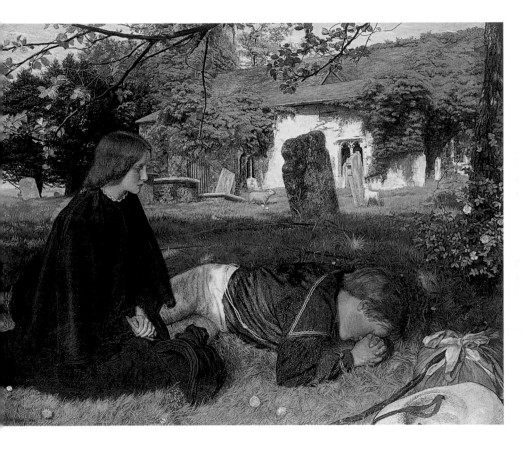

and admire the painting when it was still on the easel. Later, in 1855, their master and counsellor Madox Brown touched the hearts of the crowd with his *Last of England*. He depicted a young couple on a sailing ship, leaving their home country with an expression of deep despair on their faces. As for Rossetti, he had not exhibited anything since 1850, but at the end of 1856, feeling that success was certain, he reappeared in public and was greeted with enthusiastic applause. This was not at the Academy, but at an exclusive Pre-Raphaelite exhibition that brought together the principal works

London Bridge on the Night of the Marriage
of the Prince and Princess of Wales

William Holman Hunt, 1863-1866
Oil on canvas, 65 x 98 cm
The Ashmolean Museum of Art and Archaeology,
University of Oxford, Oxford

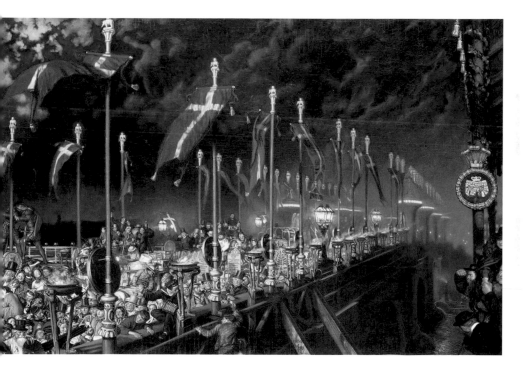

of the Brotherhood. On that day he presented the first watercolour of *Dante's Dream,* which remains one of Rossetti's most significant works. Hughes had just come on the scene with his triptych *Eve of St Agnes,* inspired by a poem by Keats. Numerous artists hurried to line up under the revolutionary flag. Philosophers and poets, Carlyle, Tennyson, Coventry Patmore, and Dickens himself, the old adversary from the early days, escorted the triumphant victors. Finally, three young men, whose future roles were as yet unknown, arrived from Oxford and asked Rossetti to lead them toward the ideal: they were called Swinburne, William Morris, and Burne-Jones.

The First Madness of Ophelia

Dante Gabriel Rossetti, 1864
Watercolour on paper, 39.4 x 29.2 cm
Charles Lees Collection, Gallery Oldham, Oldham

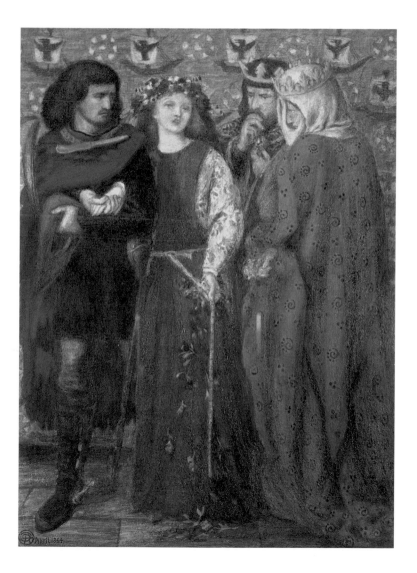

The Pre-Raphaelites amused themselves making portraits of one another, as soldiers might admire one another and celebrate victory once the battle has ended. And this was certainly a victory. It has been calculated that Millais, Hunt, and Rossetti earned no less than twelve million pounds between the three of them. But this was also the end of the Pre-Raphaelite Brotherhood. For a long time, their paintings had no longer been signed with the letters P.R.B. Several of the Brothers had left London: Woolner to go to Australia, Hunt for Palestine,

How Sir Galahad, Sir Bors and Sir Percival
Were Fed with the Sanct Grael; but
Sir Percival's Sister Died by the Way

Dante Gabriel Rossetti, 1864
Watercolour on paper, 29.2 x 41.9 cm
Tate Britain, London

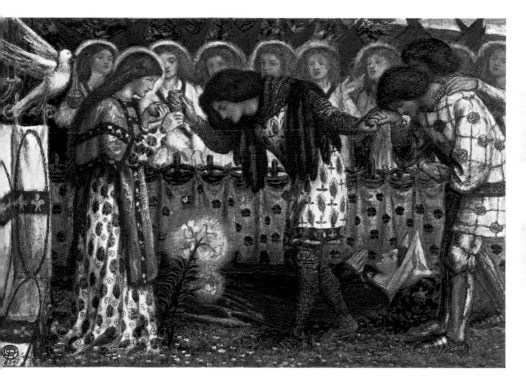

and Collinson to take refuge in a monastery. Deverell died and, at that moment, the group split apart. In 1857, two of the absent Brothers returned, but among those who had not left their country, one of the greatest was distancing himself imperceptibly from the Pre-Raphaelite ideal. To the applause of the academic world, he was creating a more independent and important place for himself; this was Millais. Ruskin noticed Millais' defection and raised the alarm, but in vain. Thus, the year 1857 is a decisive date in history, like the year 1846.

Morgan-Le-Fay

Frederick Sandys, 1864
Oil on panel, 61.8 x 43.7 cm
Birmingham Museum and Art Gallery, Birmingham

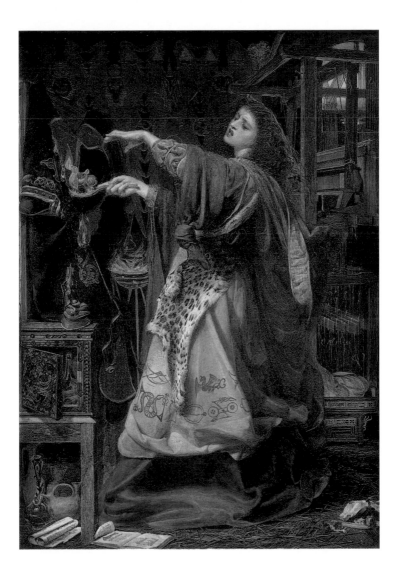

In 1846, Haydon, the head of the Royal Academy School, committed suicide, and Madox Brown had just exhibited his *William the Conqueror*. In 1857, Madox Brown's school had triumphed and Millais, the head of that school, committed moral suicide. The entire 1850 movement can be situated between these two dates. In 1846, a man sought to create a new movement but was not yet able to amass an army. In 1857, they had all turned to their own specialisations, like soldiers returning home. The troops were dismissed, for they had nothing more to do: Pre-Raphaelitism was victorious.

In the Grass (second version)

Arthur Hughes, 1864-1865
Oil on canvas, 26.5 x 35.5 cm
Sheffield City Art Galleries, Sheffield

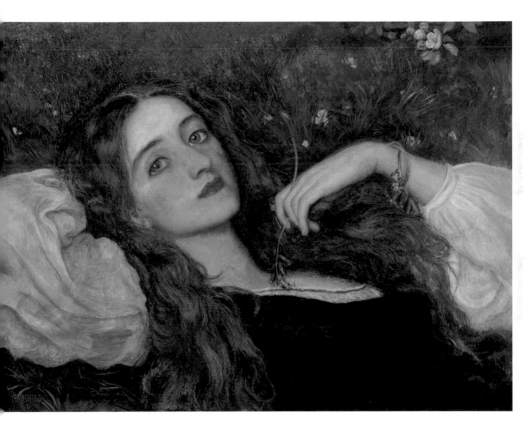

THE DEFINITION AND RESULTS OF
PRE-RAPHAELITISM

But who exactly was this victor? For "Pre-Raphaelitism" is a term that is more mysterious than explicative, and it should be discussed now that the battle has been won, in order to understand what it meant and what happened during the struggle to lead to its acceptance. It was composed of the most diverse and contradictory elements. There was contempt for Raphael, though Hunt, who is not only

Venus Verticordia

Dante Gabriel Rossetti, 1864-1868
Oil on canvas, 98 x 70 cm
Russel-Cotes Art Gallery and Museum, Bournemouth

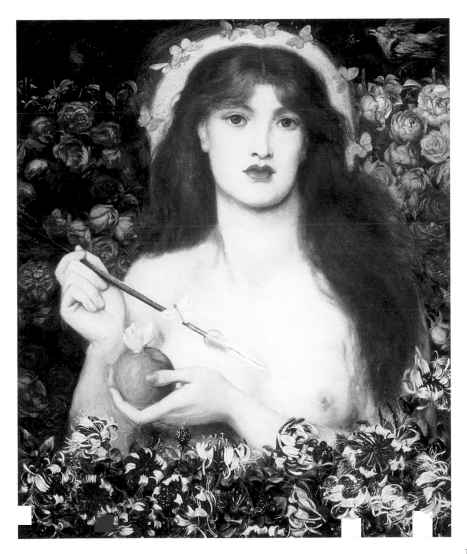

one of the Pre-Raphaelites, but the Pre-Raphaelite *par excellence,* tells us in his memoirs that it was the Raphaels in the National Gallery that he admired most in his youth. There was a preference for imitating the thin, hard style of the Primitives, whereas a single glance at the ample bosoms, round shoulders, and sensual mouths of Rossetti's women evokes all the opulence and splendour of the Renaissance. There was realism, "uncompromising truth", forbidding the addition of any imaginary element, but it is precisely the imaginary that is striking when one admires some of the school's works, such as

Beata Beatrix

Dante Gabriel Rossetti, c. 1864-1870
Oil on canvas, 86.4 x 66 cm
Tate Britain, London

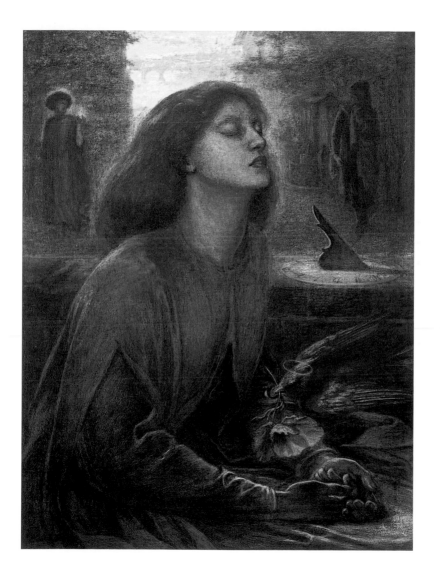

Hunt's *The Light of the World* or *Dante's Dream* by Rossetti. Some also saw a transcendent idealism, an offshoot of the great Gothic and religious revival that was called the Oxford Movement. Pre-Raphaelitism was reduced to a few processes, such as the meticulous search for the infinitesimal details that Ruskin desired and the substitution of the living model for the mannequin, with the freedom to choose the model that seemed the most appropriate to convey the idea of the Virgin, Jesus, or a hero, and the obligation, once the model was chosen, to stick to it exactly and to copy it scrupulously,

Le Chant d'amour

Edward Burne-Jones, 1865
Watercolour and gouache on paper, on panel, 56 x 78 cm
Museum of Fine Arts, Boston

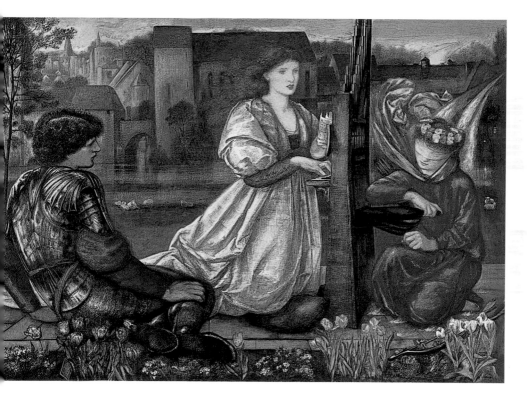

without introducing characteristics of any other figure, nor idealising it according to some memory. But this definition fails completely to include Madox Brown and Rossetti among the Pre-Raphaelites. For Madox Brown never accepted that the artist should avoid fusing several models, and Rossetti, except on two or three occasions, spent his life painting his figures after a mannequin or even after nothing at all, "out of his own consciousness". Finally, tired of inventing definitions that all exclude some of the objects to be defined, certain critics elevated

La Belle Dame Sans Merci

Walter Crane, 1865
Oil on canvas, 46.3 x 56.5 cm
Private collection

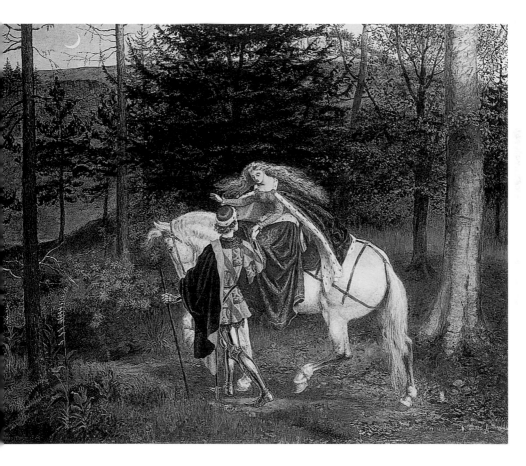

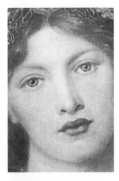

themselves to very general reflection. "Yes," cried one of them, "the Pre-Raphaelite movement was more than a revolution in the ideals and methods of painting. It was a single wave in a great reactionary tide – the ever-rising protest and rebellion of our century against artificial authority, against tradition and convention in every department of life. It broke out, socially, with the French Revolution; it spread from ethics to politics, it touched all morality and all knowledge, and it affected the whole literature of Europe from philosophy to fiction and from the drama to the lyric poem.

The Beloved (The Bride)

Dante Gabriel Rossetti, 1865
Oil on canvas, 80 x 76 cm
Tate Gallery, London

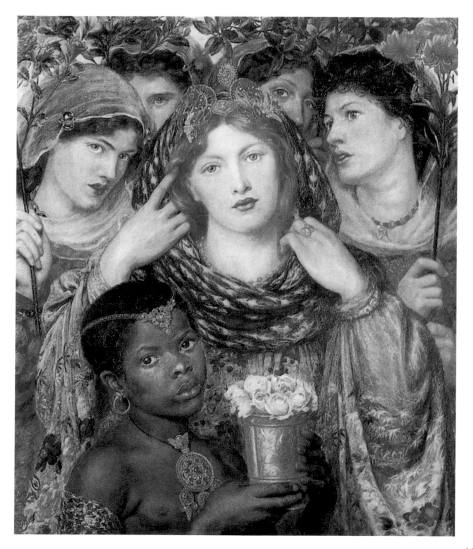

Schumann and Chopin breathed it into music. Darwin, by reforming the world of science, laid down in the theory of evolution the basis of this new cosmogony…" Here, one loses one's footing entirely. A school of art that resembles so many things outside art is not clearly differentiated enough from its rivals that, when it is described, one can recognise a painting that belongs to it. The definition of Pre-Raphaelitism is too narrow if we restrict it to the quest for detail, but becomes too large if we extend it to the conquest of a new philosophy.

Cupid finding Psyche

Edward Burne-Jones, 1865-1887
Watercolour, gouache, and gold paint, 69.4 x 49.4 cm
Manchester City Art Gallery, Manchester

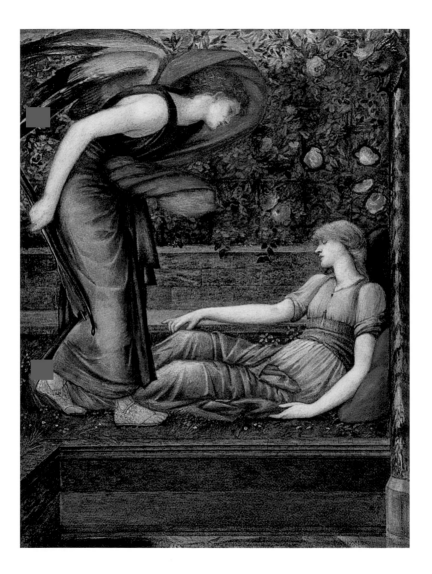

Rossetti, in keeping only rarely to the rules that he himself had laid down, proved that in his eyes, painstaking realism was not the goal of art. Millais, by abandoning the Pre-Raphaelite theories starting at the age of twenty-eight, showed even more clearly that he considered them to be constraints from which he should one day free himself. Hunt thinks in exactly the same way: "In agreeing to use the utmost elaboration in painting our first pictures," he said, "we never meant more than to insist that the practice was essential for training the eye and hand of the young artist;

Cupid delivering Psyche

Edward Burne-Jones, 1867
Watercolour and gouache, 54.1 x 61 cm
Cecil Higgins Art Gallery, Bedford

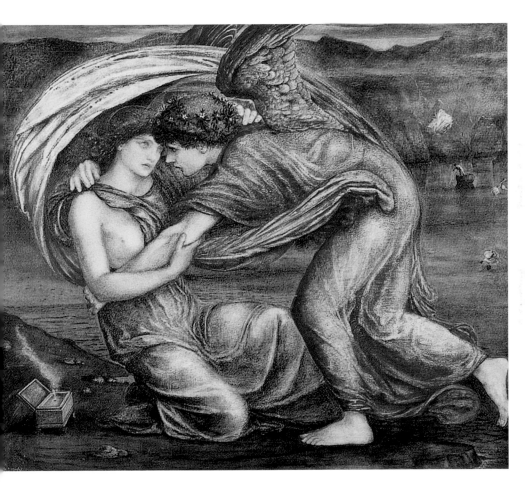

we should not have admitted that the relinquishment of this habit of work by a matured painter would make him an apostate Pre-Raphaelite." Finally, even Ruskin, who has often been accused of exaggeration, pointed out as early as 1843, in the book that the young Hunt read at night, that the realistic study of nature was in his opinion only a training method. It is therefore neither shocking nor extraordinary that Madox Brown, who was more knowledgeable than his followers, did not constrain himself to their method, or that Rossetti left it behind rather early, after one or two half-works,

Isabella and the Pot of Basil

William Holman Hunt, 1867
Oil on canvas, 185 x 113 cm
Laing Art Gallery, Newcastle

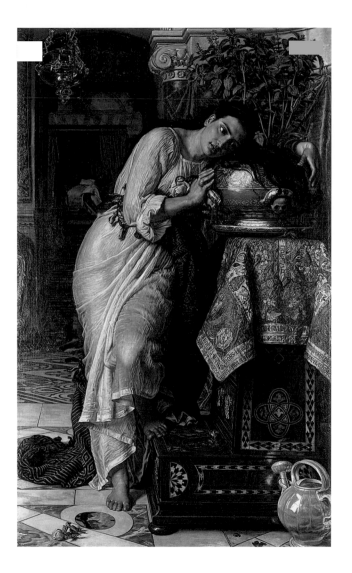

such as *The Annunciation* and *Found,* or that Millais did the same a few years later. There is no Pre-Raphaelite that did not, at some time, ignore the realist method. Identifying Pre-Raphaelitism with the Pre-Raphaelite theory of the early days leads to the conclusion that the movement was abandoned by all of its members.

Thus, there was something more lasting than the Pre-Raphaelite theory. There was an idea that united these innovators more closely and guided them for longer. But in order to find it, one must leave theory behind and examine their practices,

Paolo and Francesca

Dante Gabriel Rossetti, c. 1867
Watercolour on paper, 43.7 x 36.1 cm
National Gallery of Victoria, Melbourne

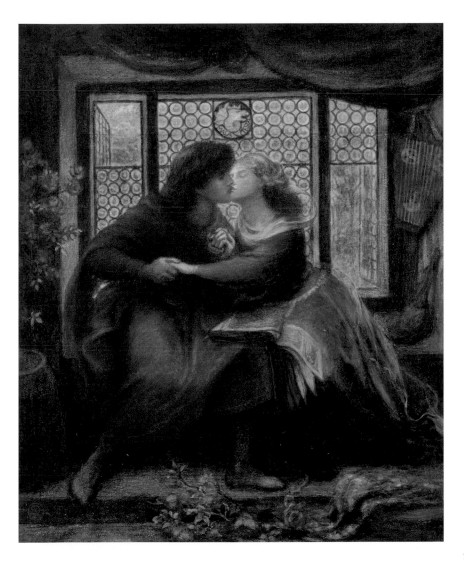

one must judge them not by their words, but by their deeds, by their works. Then one sees, in all of them, and to the same degree, a furious effort, a desperate attempt to escape the inexpressive gestures and lifeless colours of the Academy in 1850. Whatever work one stands before, whatever master one chooses, at whatever period one considers his work, excepting the second half of Millais' life, one finds these two characteristics: original poses and brilliant colour. The heads are perhaps inclined too far in meditation, the arms are sometimes subtly more rounded than necessary to

Cordelia's Portion

Ford Madox Brown, 1867-1875
Oil on canvas, 55.9 x 77.2 cm
The Fitzwilliam Museum, Cambridge

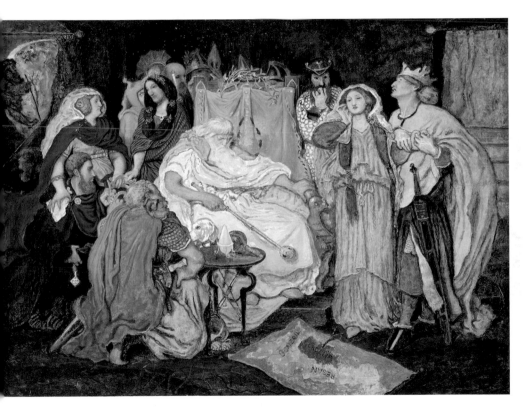

159

attain a novel pose and express something new with the human body, like the branches of fruit trees that are forced into certain strange poses along a trellis. This desire to delve into the meaning of the slightest gestures, to restore meaning to the most vulgar interplay of muscles, is often carried to the point of mania. But on the other hand, this insistence on original poses often simply means remaining true to nature and changing the false aspect of a classical pose. The colours sometimes shriek from being juxtaposed without transition, from being left raw and unconcealed,

Le Chant d'amour

Edward Burne-Jones, 1868-1877
Oil on canvas, 114 x 155.9 cm
The Metropolitan Museum of Art, New York

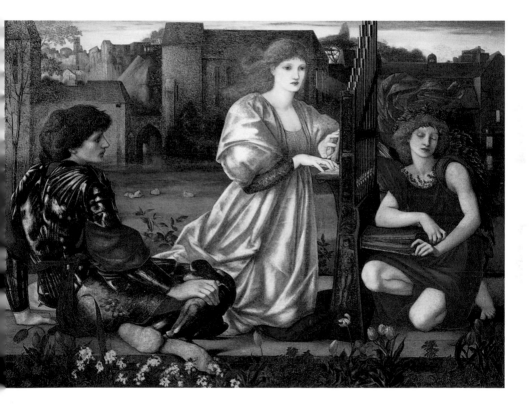

and the brushstrokes, clumsily applied while working towards a difficult shade, are upsetting to look at, as the painter's prejudices kept him from covering up his laborious process of trial and error. But, beneficial or not, these same characteristics are seen everywhere. Whether or not these are faults, the expressive originality of poses and the raw brilliance of colour can be seen in any Pre-Raphaelite painting, while they are completely lacking in the works that preceded them. They can be seen in Madox Brown's work *Christ washing Saint Peter's Feet*, in Saint Peter's deeply bowed head,

Found

Dante Gabriel Rossetti, begun in 1869 (unfinished)
Oil on canvas, 76.2 x 88.9 cm
Samuel and Mary R. Bancroft Collection of Pre-Raphaelite Art,
Delaware Art Museum, Wilmington

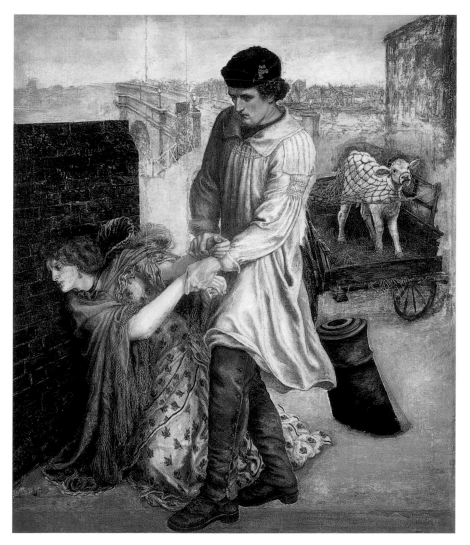

in his furrowed brow, in his knees bent up under his chin and his hands joined around his knee, in all these aspects of the human machine straining to express the state of difficult reflection that envelops the apostle. This is the same highly significant pose that Holman Hunt would later give to the Rabbi Johanan ben Zakkai, who is listening to the boy Jesus in the Temple. The desire for brilliant colour can be found in the virulence of the basin's copper tones and in Saint Peter's feet. These characteristics are again found in Rossetti's *Beata Beatrix*, only a few steps away from Madox Brown's *Saint Peter*.

Elaine

Edward Burne-Jones (design) and Morris,
Marshall, Faulkner & Co. (production), 1870
Stained and painted glass,
86.3 x 51.4 cm
Victoria and Albert Museum, London

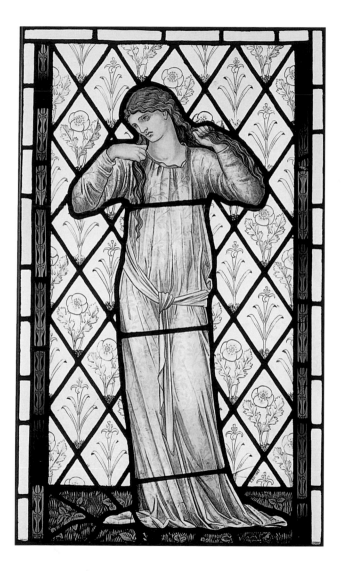

Her head tilts painfully back, her throat opens out like a fan, her eyelids are half lowered and her mouth is half open, her hands rest passively on her knees in an attitude of excessive languor and prostration. She is entirely coloured in green, red, orange, and violet tones, extremely bright, but strong, solid, and even light when compared with the browns of the academic school. We find these characteristics in all of Hunt's works, and also in those of Millais until well after he is supposed to have abandoned Pre-Raphaelitism. It is simply that they were achieved by a great variety of means.

Mariana

Dante Gabriel Rossetti, 1870
Oil on canvas, 109.8 x 90.5 cm
Aberdeen Art Gallery & Museums, Aberdeen

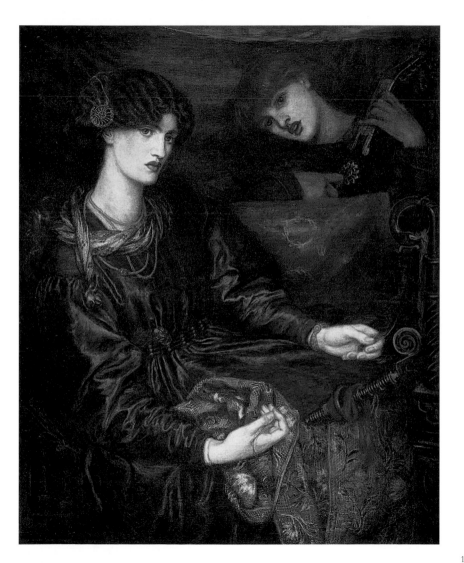

Some, such as Hunt and Millais early on, sought to attain original poses through the scrupulous observation of nature. Rossetti obtained the effect by reaching deep into his mind, straining his imagination, and forbidding his dream to speak until he had completely stripped it of all acquired forms, of all things drawn from the masters' paintings. Thus he rarely painted his figures after nature, and many of them came directly from his imagination. Hunt and Millais sought new, varied, strong colours from the landscapes of Surrey,

Phyllis and Demophoön

Edward Burne-Jones, 1870
Watercolour and gouache, 91.5 x 45.8 cm
Birmingham Museum and Art Gallery, Birmingham

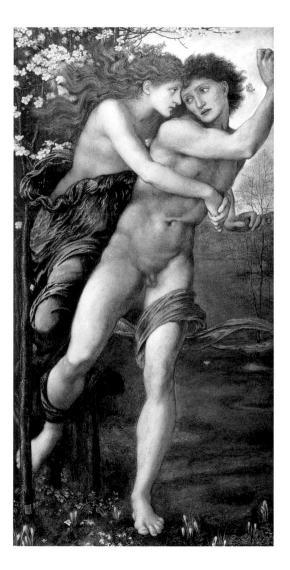

which they observed and copied in *plein air*, while Rossetti obtained them through audacious experiments in the studio, unexpected juxtapositions, and continuous changes in his palette, excursions whose futility often drove him to despair.

Finally, we find these characteristics in the work of one of their contemporaries, one of the winners of the Westminster competition 1844, who is never mentioned among the Pre-Raphaelites because he was neither a member of the Brotherhood nor one of its close friends. Working alone, he simultaneously

The Shadow of Death

William Holman Hunt, 1870-1873
Oil on canvas, 281 x 248 cm
Manchester Art Gallery, Manchester

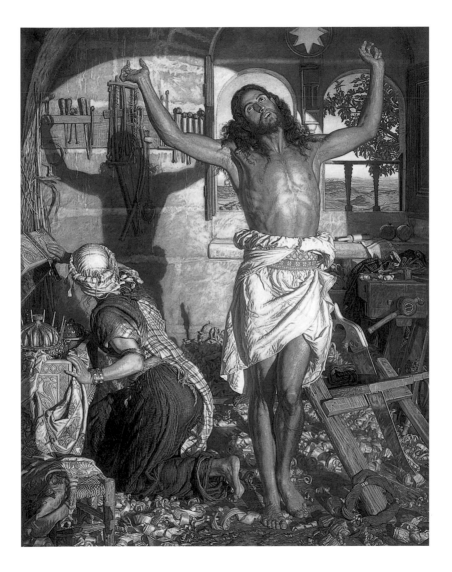

accomplished the same reform as the Pre-Raphaelites through the same methods. I am speaking here of George Frederick Watts. He was older than most of the P.R.B., and had deplored the colourist practices of the Academy for even longer than they had. He sought the same things as they did, original poses and strong colours, at the same time that they did, and though he was not a member of their group, its spirit was a continuous inspiration to him.

Thus, taken as a whole, from Madox Brown to Millais and from Watts to Rossetti, the 1850 movement was the following: new men seeking

Ophelia

Arthur Hughes, 1871
Oil on panel, 33.3 x 21.1 cm
The Ashmolean Museum of Art and Archaeology,
University of Oxford, Oxford

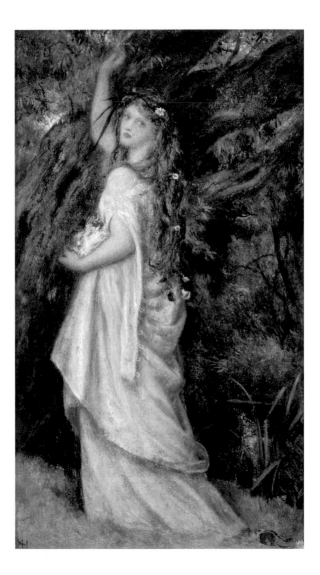

a new art, substituting curious, individual, novel poses for banal and generalising ones; and strong colour applied without underpainting, glittering with juxtapositions, for fluid colour reinforced by superpositions. In short, expressive lines instead of decorative ones and bright colours instead of warm ones. This, put simply, is what Pre-Raphaelitism was.

The P.R.B. often passed quite close to modern discoveries, and several times they stammered out the first words of an aesthetic revolution. We have the same impression when looking at them as when reading Vauban's *Dixme Royale*; this is a

The Bower Meadow

Dante Gabriel Rossetti, 1872
Oil on canvas, 86.3 x 68 cm
Manchester Art Gallery, Manchester

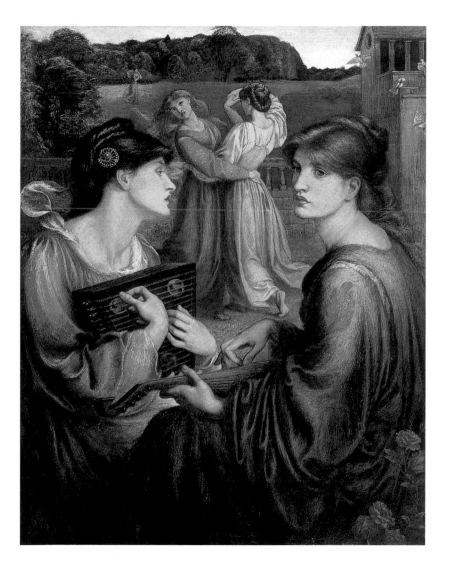

new world, not yet clearly visible, but half-revealed through prophecy and premonition. Thus, it is incorrect to say that by reducing Pre-Raphaelitism to original lines and bold colours, we lessen its role; on the contrary, we enlarge it. The name of the Pre-Raphaelite magazine was well chosen, for their work contained the *Germ* of all contemporary painting.

Whatever their theories or those of their friends were, whatever goals they established or were identified with, the Pre-Raphaelites profoundly changed the idea of line and colour for their compatriots.

The Beguiling of Merlin

Edward Burne-Jones, 1872-1874
Oil on canvas, 186 x 111 cm
Lady Lever Art Gallery, Liverpool

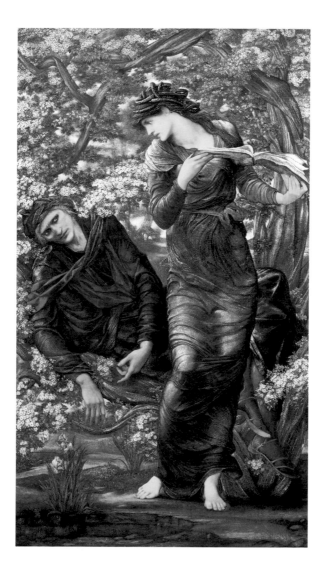

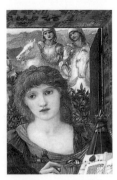

Perhaps without knowing it, and certainly without understanding very clearly, they introduced in England the habit of clearly expressing a subject through meaningful poses and pursuing vivid colour with simple, direct means. Could this give England new masterpieces? We can respond only by looking at the principal manifestations of contemporary English painting, but it surely must have given England new works and a national art. Perhaps they could not prove that nature is the last word in art, but they proved that it is the first, and that the efforts of a host of talented and strong-willed men, whatever the goal that they choose may be, are never wasted.

Laus Veneris

Edward Burne-Jones, 1873-1875
Oil on canvas, 122.5 x 183.3 cm
The Laing Art Gallery, Newcastle upon Tyne

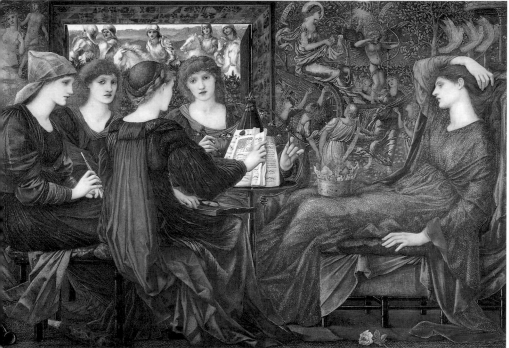

INTENTIONS

What then does such a singular art aim at? Obviously something other than merely pleasing the eyes. "You will find that the art whose end is pleasure only," says Ruskin, "is pre-eminently the gift of cruel and savage nations, cruel in temper, savage in habits and conception; but that the art which is especially dedicated to natural fact always indicates a peculiar gentleness and tenderness of mind." "The greatest art creates beauty, but does not make beauty its purpose," adds Collingwood.

Vittoria

Lord Leighton, c. 1873
Oil on canvas, 23.5 x 18 cm
Private collection

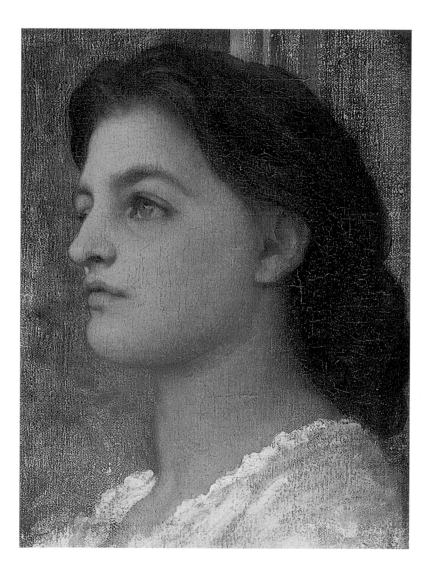

181

Thus English painting has a goal that can shed some light on its distinctive features, a programme which is not that of depicting beautiful torsos and rich draperies. One is convinced, when looking at these masters' works, as when reading those of their critics, that this extra-aesthetic goal has a high place, perhaps the highest, among their preoccupations.

This goal is first of all to address all the faculties of man: spirit, intelligence, memory, conscience, heart, and not only that part of us which sees,

The Picture Gallery

Sir Lawrence Alma-Tadema, 1874
Oil on canvas, 218 x 166 cm
Towneley Hall Art Gallery and Museum, Burnley

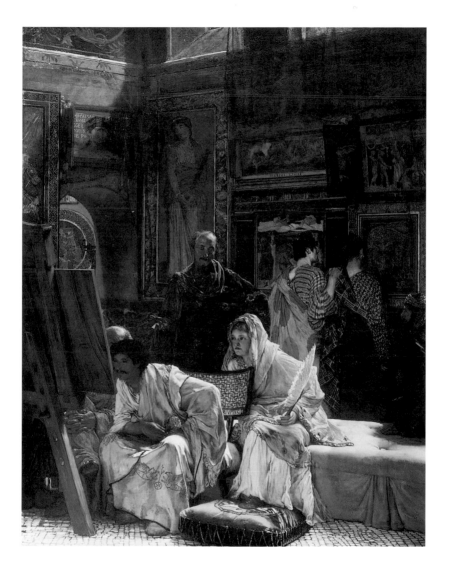

which is moved by seeing, and which imagines. "Art," said Mrs Russell Barrington, "should elevate us through its imagery to a more complete view of the human condition than that provided by everyday life." To do this, the artist himself must have a complete form of intelligence. William Morris, who made tapestries and stained glass, was also a fine poet and the most appealing writer for the socialist party. Leighton spoke many languages. Burne-Jones, who went to Oxford, was an exquisite scholar of legendary literature, Watts was a philosopher,

The Wheel of Fortune

Edward Burne-Jones, 1875-1883
Oil on canvas, 200 x 100 cm
Musée d'Orsay, Paris

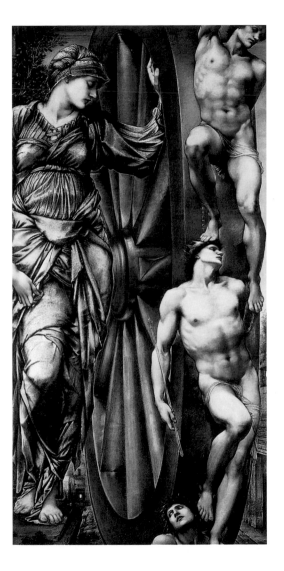

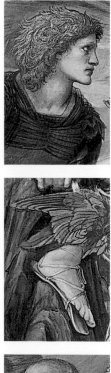

Hunt was an exegete, and Alma-Tadema was an archaeologist. Millais and Herkomer both brilliantly expressed ingenious ideas on all the arts, and the latter lectured on them at Oxford. We are struck by the breadth of their culture. All of the questions pronounced in this world found an intelligent echo in their studios. Such artists could act upon all of the spectator's faculties because all of theirs were active, and they could teach a lot because they had themselves learned much.

Perseus and the Sea Nymphs
(The Perseus Cycle)

Edward Burne-Jones, 1877
Gouache on paper, 152.8 x 126.4 cm
Southampton City Art Gallery, Southampton

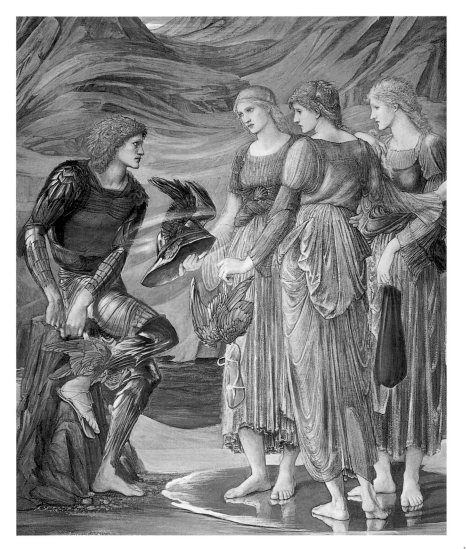

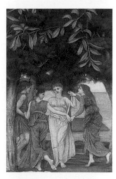

What they taught us is above all their idea of work. The sort of improvisationist who makes a horse or a *Harmony* in two days, like Fromentin or Whistler, and who asks two hundred guineas for it under the pretext that he has been preparing it for thirty years, is extremely rare among the English. Most of their artists share a disdain for easy success, are persistent in their work, and are determined to never be satisfied so long as they still find something better in themselves than in their work. Madox Brown spent four years making his *Last of England*,

Love and the Maiden

John Roddam Spencer Stanhope, 1877
Tempera, gold paint, and gold leaf on canvas, 137.2 x 200.7 cm
Fine Arts Museums of San Francisco, San Francisco

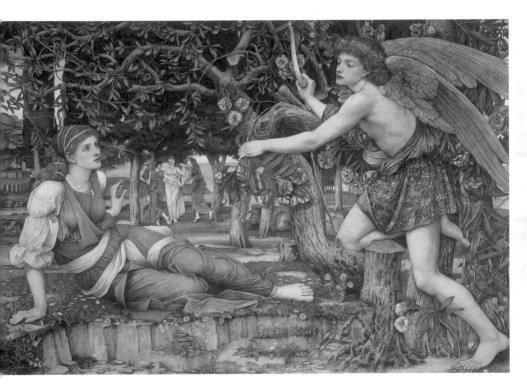

which includes only two main figures, and fifteen years painting the frescoes in Manchester Town Hall. Hunt spent an entire life of continuous labour on a few small paintings, as many as some painters exhibit in a year on the Champs de Mars or in a club. Watts painted hundreds, but he kept all of them in his studio, considering that only two out of this number did not need any retouching. One must read Mr Hamerton's stories about camping in the moors of Lancashire to imagine the effort and time

An Angel playing a Flageolet

Edward Burne-Jones, 1878
Watercolour, gouche, and gold, 74.9 x 61.2 cm
Sudley House, Liverpool

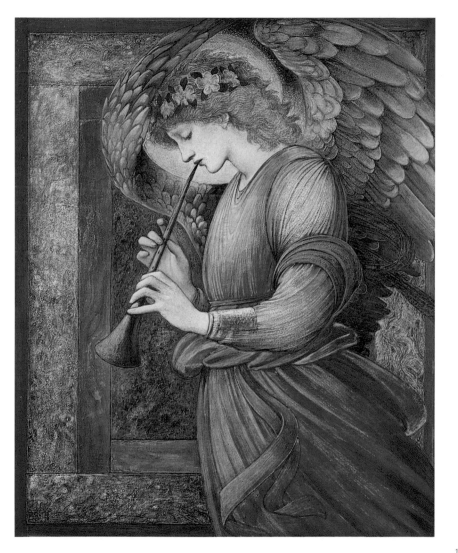

that a Pre-Raphaelite could devote to studying a tuft of ferns in the field, frond by frond. In his tar-sealed wood and tile hut, which predated Mr de Nittis's famous *roulotte* by ten years, Mr Hamerton had to endure cold, humidity, gusty wind, the curiosity of peasants who came along, believing that they had seen him executing the turns and attacks of night hunters, and the inane questions of neighbouring country gentlemen, and all of this for months on end.

Pygmalion and Galatea III: The Godhead Fires
(Pygmalion and the Image)
— — —
Edward Burne-Jones, 1878
Oil on canvas, 143.7 x 116.8 cm
Birmingham Museum and Art Gallery, Birmingham

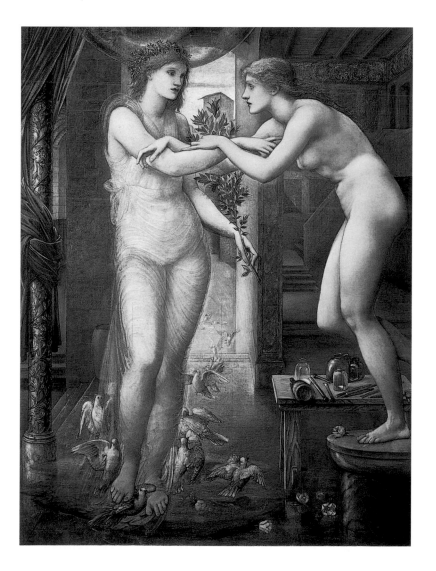

193

Alma-Tadema was very productive, this is true, but he professed and proved through his own example that nothing is accomplished without difficulty. He showed no leniency toward his own work. In 1859, one of his paintings sent to the Brussels exhibition was refused by the jury. It depicted a fire. He asked his friends to come see this painting in his studio, to tear holes in it, and pass through it like a door. He gave the example himself, by jumping headfirst into the flames of his painting. This joking about was not without courage. It demonstrated the necessity of effort,

Pygmalion and Galatea IV: The Soul Attains
(Pygmalion and the Image)

Edward Burne-Jones, 1878
Oil on canvas, 99 x 76.2 cm
Birmingham Museum and Art Gallery, Birmingham

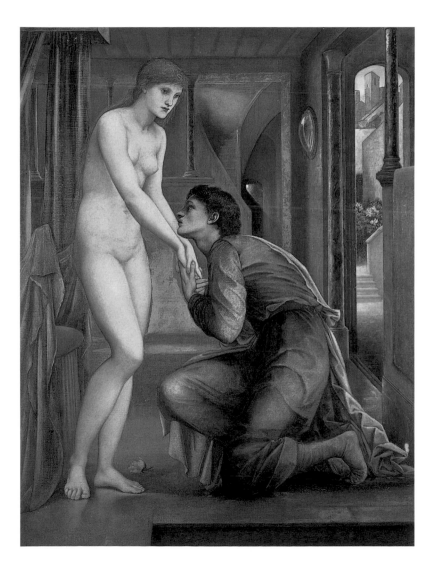

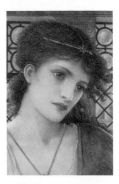

the price of steadfastness, and the strength of the will. This was the first lesson given by English painting. It has others to offer, numerous and useful, about the phenomena of nature, the events of history, and the meaning of life. "All great art is to some degree didactic," said Ruskin. Here we have the explanation, and to a certain degree the excuse, for the minute details and prodigious accessories that encumber most English paintings to the detriment of the whole. They are intended to teach the onlooker.

Isabella and the Pot of Basil

John Melhuish Strudwick, 1879
Private collection

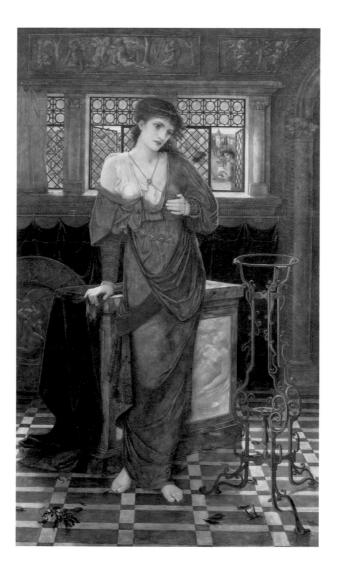

197

It is not out of conceit over his ability, dexterity, and virtuosity that the English painter studies every detail of a flower or a rock; it is so that a dicotyledone is not confused with a monocotyledone, or a granitic terrain with a schistose terrain. This last point reveals the depths of English thought. Art should be didactic, but this is not an end in itself. It is because by using the minute to show us how admirable creation is, it inspires us to praise our Creator. Ruskin, already an old man, wrote on 16 September 1888,

The Laidley Worm of Spindleston Heugh

Walter Crane, 1881
Oil on canvas, 74.5 x 169.5 cm
Private collection

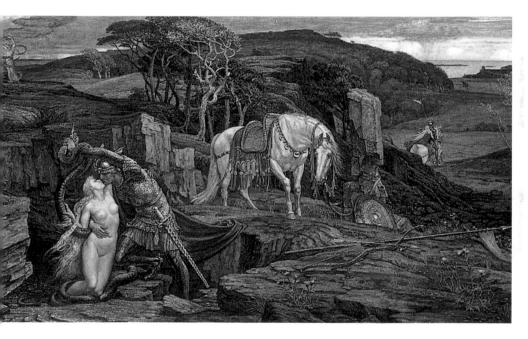

in Chamonix: "All that is involved in these passionate utterances of my youth was first expanded and then concentrated into the aphorism given twenty years afterwards in my inaugural Oxford lectures: All great Art is Praise."

But though this is quite a beautiful purpose, it appears at first glance to be somewhat fanciful. The majority of the people are neither artists nor truly capable of enjoying works of art. But they should be; and this is the most original idea that contemporary England has on art, its creation, and its usefulness.

The Death of Medusa I
(The Perseus Cycle)

Edward Burne-Jones, c. 1882
Gouache, 124.5 x 116.9 cm
Southampton City Art Gallery, Southampton

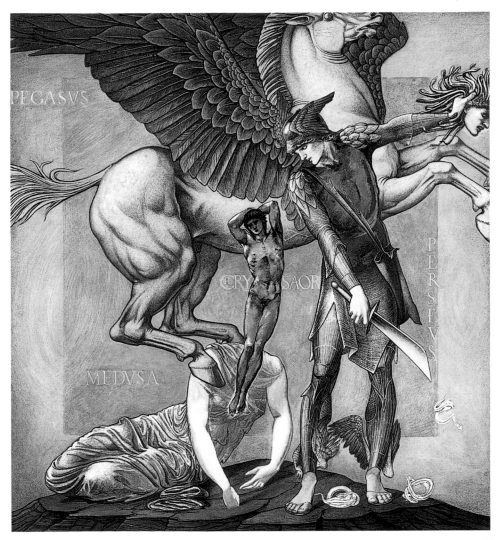

PEGASVS

CRYSAOR

MEDVSA

PERSEVS

According to them – Ruskin, Burne-Jones, William Morris, Walter Crane, Richmond, Holiday, and all the neo-Pre-Raphaelites – all the members of a democracy should take part in the infinite moral pleasure provided by aesthetics. Art, according to their principles, should be both very noble and very democratic; it should say the most philosophical things, and say them to everyone. It should elevate the man who produces it, that is to say everyone, because it should be produced by everyone, and it should elevate those who appreciate it,

The Death of Medusa II
(The Perseus Cycle)

Edward Burne-Jones, c. 1882
Gouache, 152.5 x 136.5 cm
Southampton City Art Gallery, Southampton

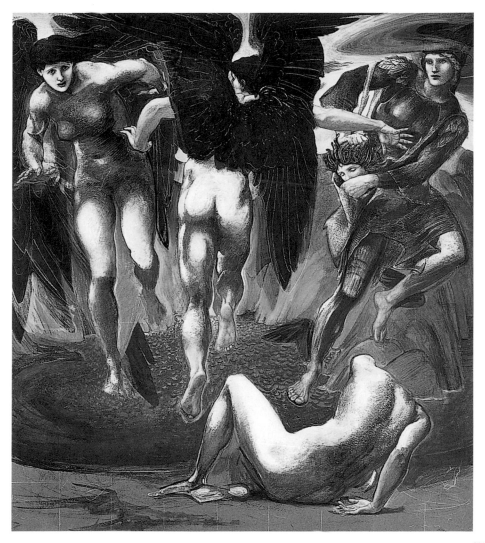

again everyone, because everyone is called to appreciate it. But how can a workman, a carpenter, a mason, or a weaver offer himself artistic pleasure? First of all, by creating artworks, respond the English. But to do so, it was not at all necessary that he become a painter or perform music. He must simply introduce an aesthetic element into his craft, the humble work with which he has been entrusted. Morris went on: "The development of the lower classes should not be gone about backwards, by giving the workmen museums and concerts, but by giving

Antony and Cleopatra

Sir Lawrence Alma-Tadema, 1883
Oil on canvas, 65.4 x 92.1 cm
Private collection

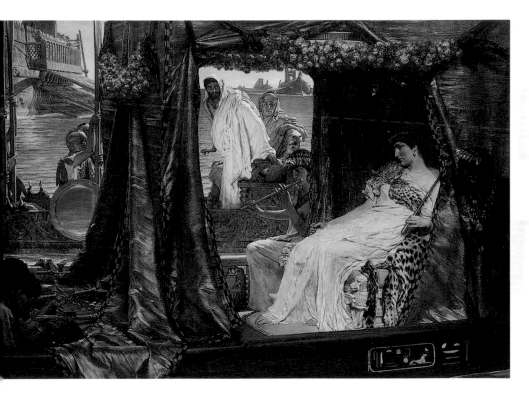

them back their primitive role, by striving to make homes, clothing, utensils, furniture, and all the tools of daily life both useful and beautiful for everyone. What is an artist, if not a worker who is determined, whatever happens, to produce exceptional work? And what is the decoration of furniture, of any object, if not an expression of the pleasure that the craftsman feels from succeeding in his work?" Morris also wanted all working-class people to learn the basics of design, not the art of drawing strictly speaking, but the means towards this end;

The Triumph of the Innocents

William Holman Hunt, c. 1883-1884
Oil on canvas, 156.2 x 254 cm
Tate Britain, London

a general ability in practising the arts. If this is not sufficient for them to begin producing aesthetic designs, the artists themselves should also participate, unashamed to apply their genius to the curve of a chairback or the decoration of a pan. This is the tradition of the heroic days of art. In the past, the same man provided the mind that conceived and directed, the arms that laboured, and the expert hand that chiselled, modelled, or painted. Today, unfortunately, the different sorts of artists are as separate from one another as they are from the various other professions.

The Rock of Doom
(The Perseus Cycle)

Edward Burne-Jones, c. 1884-1885
Gouache on paper, 154 x 128.6 cm
Southampton City Art Gallery, Southampton

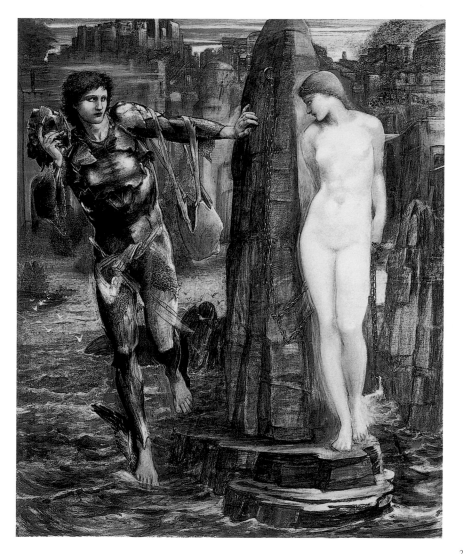

"By this division of labour," said Ruskin, "you ruin all the arts at once. The work of the Academician becomes mean and effeminate because he is not used to treat colour on a grand scale and in rough materials; and your manufactures become base, because no well-educated person sets hand to them. And therefore it is necessary to understand, not merely as a logical statement but as a practical necessity, that wherever beautiful colour is to be arranged, you need a Master of Painting; and wherever noble form is to be given, a Master of Sculpture."

Chivalry

Sir Frank Dicksee, c. 1885
Oil on canvas, 183 x 136 cm
The Forbes Magazine Collection, New York

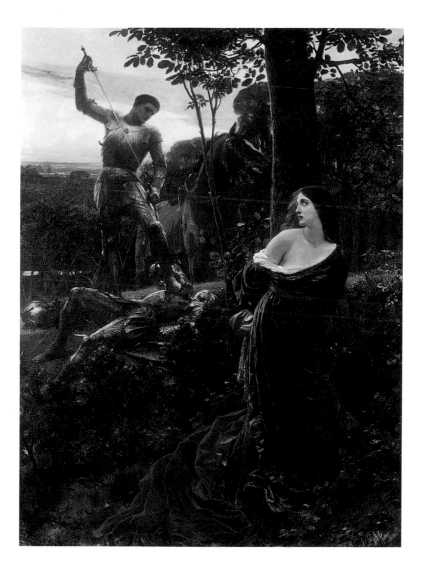

This is what the English did in the Arts and Crafts movement, at whose exhibitions a craftsman signed his work just as a member of the Royal Academy signed his paintings. Burne-Jones decorated glazed pans and pianos and painted mosaic tiles for churches. Herkomer designed elaborate decorations for plates. Walter Crane, Richmond, Holiday, and twenty others devoted their rare talents to the most common work. Looking around the restaurant of the South Kensington museum, one finds that one is in the midst of enchanting décor

The Baleful Head

Edward Burne-Jones, 1885-1887
Oil on canvas, 150 x 130 cm
Staatsgalerie, Stuttgart

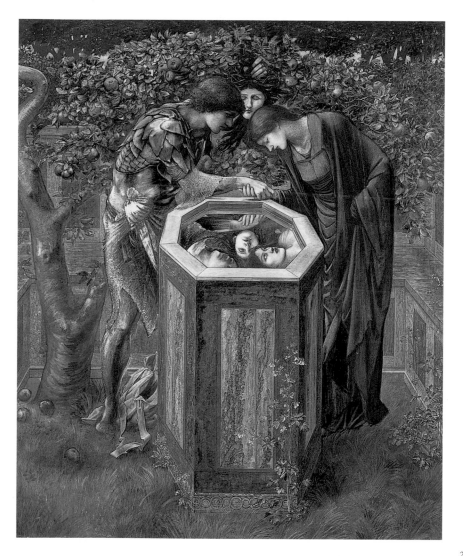

by the great poet William Morris, surrounded by figures drawn by the great symbolist Burne-Jones, and that one is eating venison with redcurrant jelly or rhubarb pie!

These are certainly noble goals, but there is one more that seems to stand out in the minds of the English, that they may speak of less, but which they think of more. It is not enough for art to be suggestive, didactic, moral, or popular; it must also be national. It must be English. Except for some rare exceptions, all great British artists are clearly

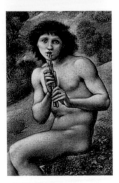

The Garden of Pan

Edward Burne-Jones, 1886-1887
Oil on canvas, 152.5 x 186.9 cm
National Gallery of Victoria, Melbourne

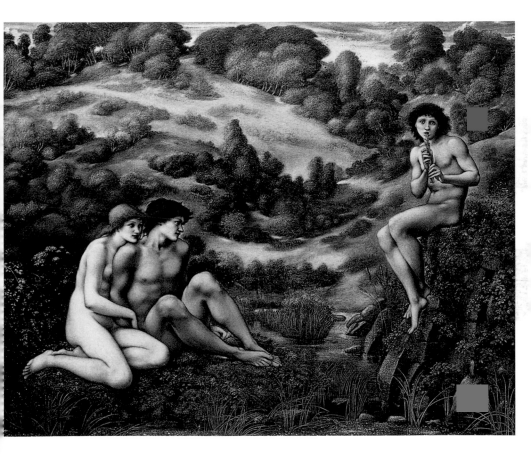

215

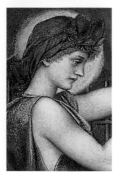

opposed to foreign (i.e. French) influence: Watts, Hunt, Burne-Jones and his entire school, Strudwick, Holiday, Stillman, Rooke, Walter Crane, Spencer-Stanhope, Spence... it is quite obvious. Mrs Barrington, praising Millais, informs us that "his feeling is invariably pure, transparent, and deeply wholesome. Fortunately, these qualities contrast with the crude scarecrows and disagreeable suggestions so prominent in the art patronised by the French." And to ensure that we know exactly what this French taste is, she warns us elsewhere that it is,

Hope in the Prison of Despair

Evelyn de Morgan, 1887
Oil on panel, 58 x 65 cm
Private collection

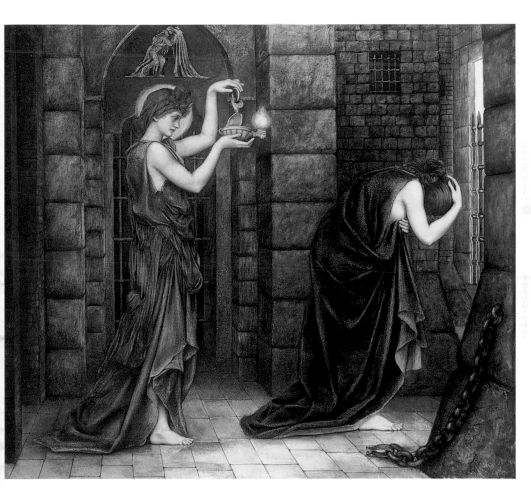

217

"in terms of sentiment, a search for mediocrity". When addressing his students, Ruskin said of the Greeks that they were "to be looked at sometimes. Not continually, and never as a model for imitation. For you are not Greeks; but, for better or worse, English creatures; and cannot do, even if it were a thousand times better worth doing, anything well, except what your English hearts shall prompt and your English skies teach you." At the opposite pole of aesthetics, Millais said: "There is among us a band of young men who, though English,

Study for "The Garden Court"
(The Briar Rose Series)

Edward Burne-Jones, 1889
Bodycolour and chalk on paper laid
onto prepared board, 89 x 59 cm
Birmingham Museum and Art Gallery, Birmingham

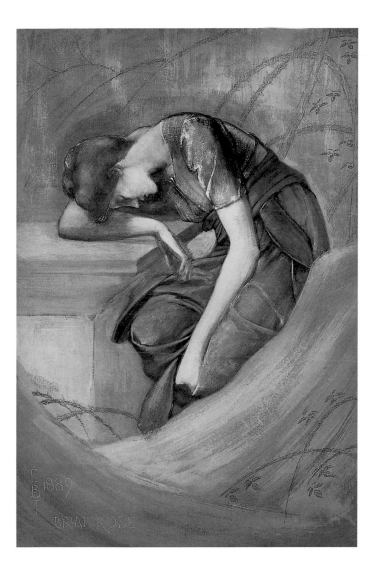

insist on painting with a broken French accent, all of them much alike, and seemingly content to lose their identity in the imitation of French masters, whom they are constitutionally, absolutely, and in the nature of things, unable to copy with justice either to themselves or their models." And none of them doubted that the hearts and skies of England could inspire art superior to that of any other period and country. "That sketch of four cherub heads from an English girl, by Sir Joshua Reynolds, at Kensington,

The Gentle Music of a Bygone Day

John Melhuish Strudwick, 1890
Oil on canvas, 79 x 61 cm
The Pre-Raphaelite Trust, London

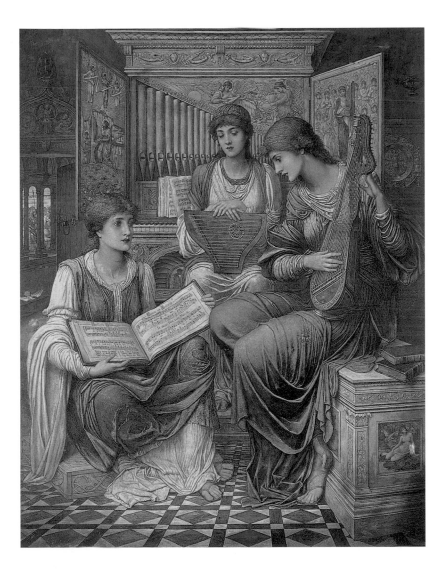

is an incomparably finer thing than ever the Greeks did," says Ruskin. Seen in this way, in its entirety, contemporary English art was born of a great effort, a tremendous obstinate aspiration toward the noble, philosophical, and national. It did not appear spontaneously, as it did in some countries, from the joy of admiring and seeing, from the happiness of forgetting, through the splendid forms of nature and the beings that fill it, the indifference of this nature, the baseness of these beings, and even the torment of our own thoughts.

The Lady of Shalott

William Holman Hunt, 1890-1905
Oil on canvas, 188 x 146 cm
Wadsworth Atheneum, Hartford

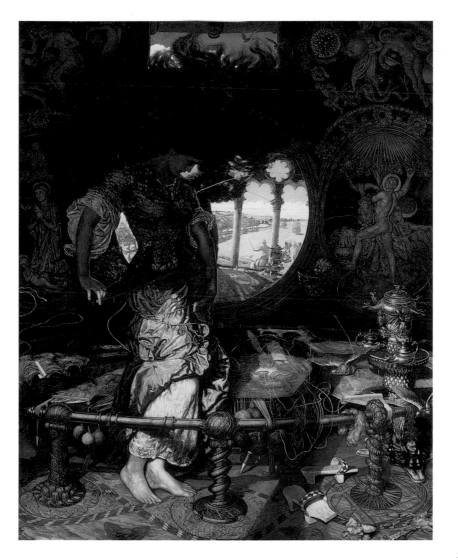

Thus, English art is related to everything: to science through its details, to psychology through its poses, to patriotism through its autonomy. It is only beauty itself to which it is not necessarily connected, and to which it does not necessarily seek to be connected. It found its inspiration in the ideas, feelings and prejudices of the most intellectual class in England. Its masters were autonomous, and if it were true that a great people expressing themselves necessarily produce great art, English art would be the greatest in the contemporary world.

La Belle Dame Sans Merci

John William Waterhouse, 1893
Oil on canvas, 112 x 81 cm
Hessisches Landesmuseum, Darmstadt

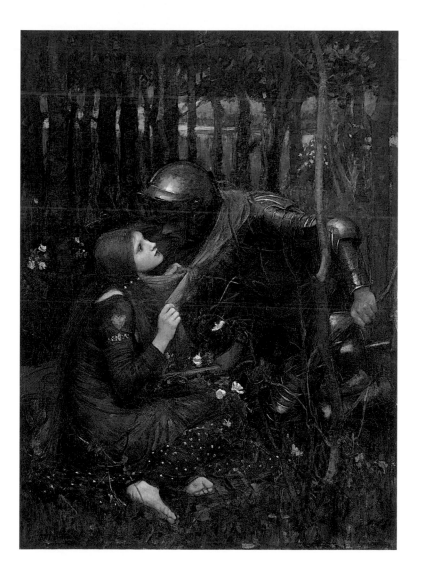

Now, should this great effort be despised or should it be imitated? Neither one nor the other. One is troubled to find that the people with the most particular point of view and the most national bearing, the people who played the most inimitable role in this world, expressed itself in vain through the fine arts: if it did not yet have the sensitive eye of a colourist and the confident hand of an illustrator, it might have produced interesting works, but never beautiful ones. When looking at these paintings, in which the suggestive side of the subject is better

The Naiad

John William Waterhouse, 1893
Oil on canvas, 66 x 127 cm
Private collection

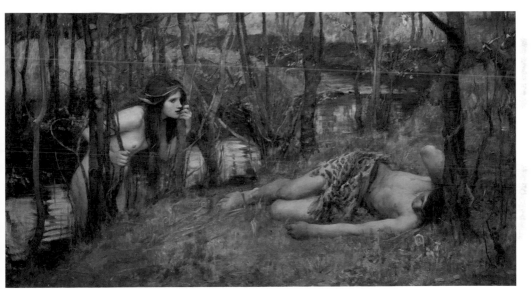

227

grasped and the plastic side more poorly grasped than perhaps anywhere else, one is troubled to see that certain theories, though upheld by the most eminent minds and applied by the most meticulous hands, have been refuted by the facts. We count these errors among those that bring more honour to humanity than many successes do, and one imagines that perhaps, they will give the nation that saw them emerge a right to success in the future. As for imitating them, this would be even worse than ignoring them.

The Challenge in the Desert

Edward Burne-Jones, 1894-1898
Oil on canvas, 129.5 x 96.5 cm
Collection Lord Lloyd-Webber

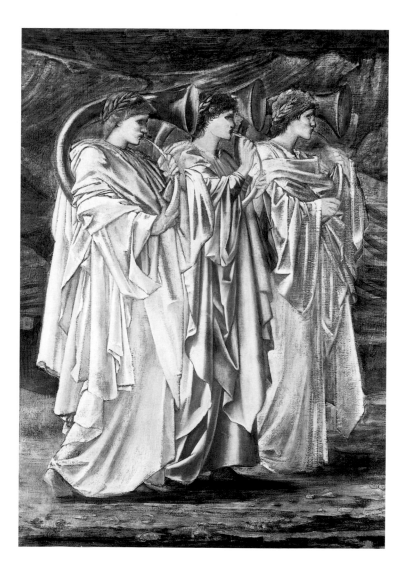

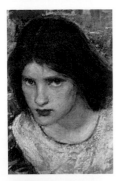

It is not that the English do not possess precisely some of the qualities that are lacking in other painters, such as the in-depth study, the serious development of a subject, and the persistent search for novel poses. If we could do in aesthetics what can be done so well now in agriculture – restore the precise life-giving element that is lacking in the soil – we could learn a lesson from their example and be supported by it. But crude imitation that amounts to a pastiche of the form given to an artist's figures, copying their features, the equilibrium of their poses,

The Lady of Shalott

John William Waterhouse, c. 1894
Oil on canvas, 120 x 68 cm
Leeds Art Gallery, Leeds

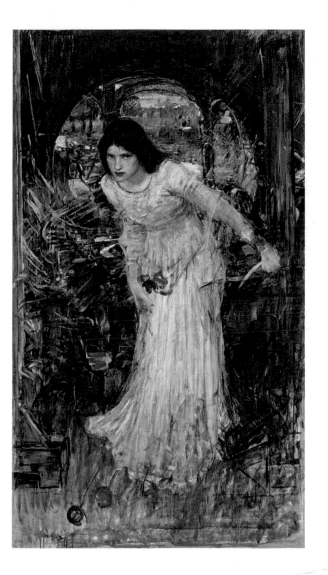

and the devices of composition, is always at fault, whether the model to be imitated is Raphael or Leonardo da Vinci. The only intelligent imitation consists of seeking inspiration in the guiding ideas of an art and not its works, observing its rules and not its examples, drawing on its sources and not its products. The Pre-Raphaelite idea is that one must be oneself; by copying any Pre-Raphaelite forms whatsoever, we become someone else. Ruskin wrote, "The only doctrine or system that I consider my own is the rejection of that which is dogmatic rather than experimental,

The Dream of Launcelot at the Chapel of St Graal

Edward Burne-Jones, 1895-1896
Oil on canvas, 138.5 x 169.8 cm
Southampton City Art Gallery, Southampton

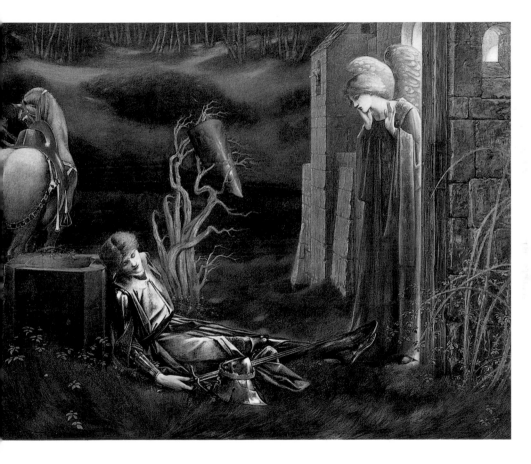

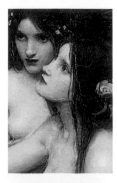

and that which is systematic instead of being useful: thus, my true followers will never be 'Ruskinian.' They will not follow my directions, but the feelings in their own souls and the will of their Creator." And all the Pre-Raphaelites thought in the same way. Consequently, to imitate them is not to understand them; to borrow their formulae is to violate their creed; to follow them is to abandon them.

So another kind of imitation is possible. It consists of drawing inspiration from the ideas that made Watts and Burne-Jones original, a return to the source from which they emerged; but this is also dangerous.

Hylas and the Nymphs

John William Waterhouse, 1896
Oil on canvas, 132.1 x 197.5 cm
Manchester Art Gallery, Manchester

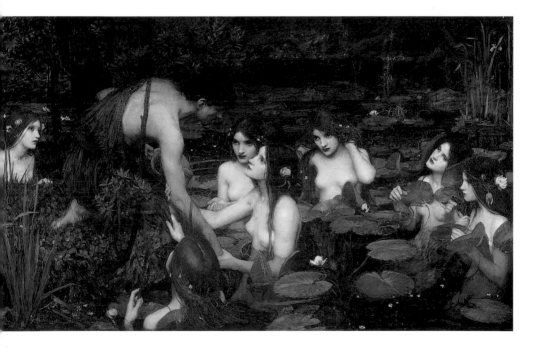

For the skilfulness and awkwardness, the tenderness and strength, even the spice and attractiveness of these masters should not make us forget that this source is artificial, and that artifice is not art. The somewhat paradoxical pleasure that we find in their deviations from nature, their refinements of grace, their exaggerations of emotion, their stylistic neologisms, their subtle grimaces, and their mysterious gestures, in all of these efforts to act on the mind rather than the eye, should not lead us out of the broad daylight of complete, honest beauty. The intellectual artist, the psychological artist,

Her Eyes are with Her Thoughts
and They are Far Away

Sir Lawrence Alma-Tadema, 1897
Oil on canvas
Pérez Simón Collection

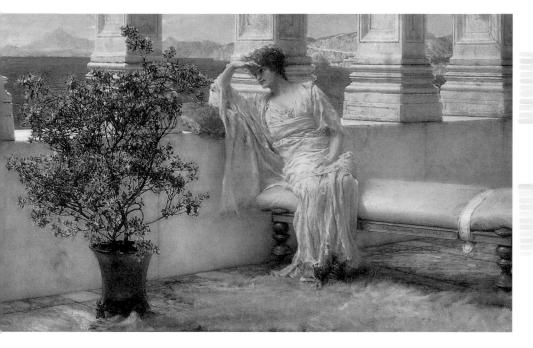

in a word the "intentionist" artist, torments himself for ten years over a great painting to express the ideas that his brother, the poet or novelist, could obtain in ten lines, and with livelier and more profound results. And during this time the painter forgets to provide us with sensations that a writer can never give.

When one walks through the Umbrian room in the National Gallery, one sees a small painting made by Raphael when he was seventeen years old, *The Knight's Dream*. A young lord, dressed in armour, has fallen asleep against a shadowless

The Wise Virgins

Eleanor Fortescue-Brickdale, 1901
Two watercolours on one canvas
upper panel: 37 x 30 cm; lower panel: 11 x 30 cm
Christopher Wood Gallery, London

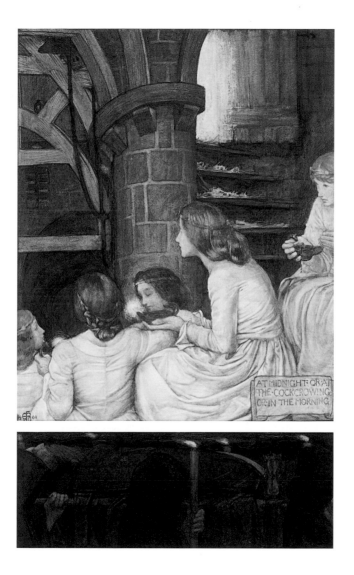

AT·MIDNIGHT·OR·AT
THE·COCKCROWING·
OR·IN·THE·MORNING·

239

laurel tree; to his left and right stand two differently dressed women. One holds out a book and an unsheathed sword, the other a flowering sprig of myrtle. The first is duty, and the second is pleasure. The handsome adolescent, at the verge of crossing the threshold into his adult life, has stopped here to sleep. He sleeps gracefully and happily on this old shield that whispers battle hymns in his ear. The two women hold their gifts out toward him, tirelessly, as if their arms were two tree branches, each holding one beautiful ripe fruit.

The Accolade

Edmund Blair Leighton, 1901
Oil on canvas, 180.9 x 108.5 cm
Private collection

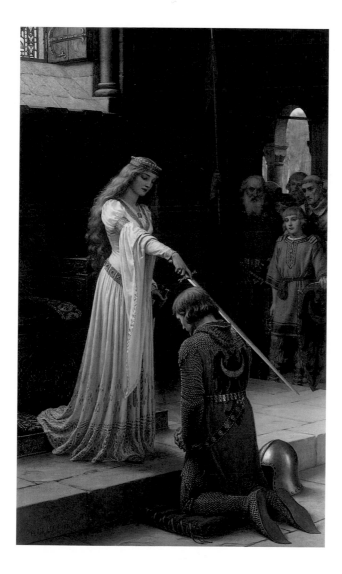

These two figures are so tempting that perhaps the clever youth would like to keep one without losing the other, to follow both of them at once, and in his state of indecision, in his unwillingness to make a choice, in order to give himself a bit more time, he does not wake, thinking that as long as they see him sleep, these two goddesses will not leave. And for four hundred years he has slept, still tempted, still undecided, and Raphael's knight will now probably never awaken. However, in the background shine beautiful blue horizons where one would love to

Midsummer Eve

Edward Robert Hughes, c. 1908
Watercolour and gouache on paper,
mounted on cardboard, 114.4 x 76.2 cm
Private collection

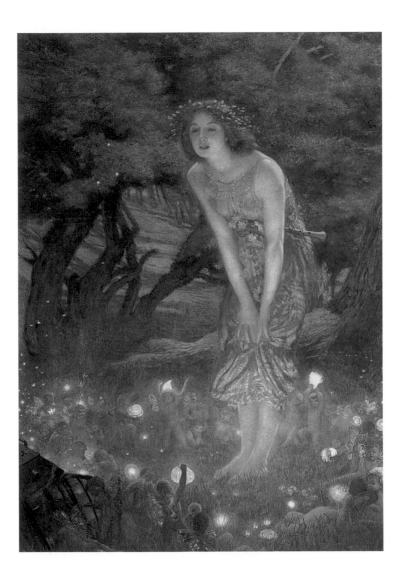

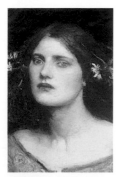

walk with one's joys and sorrows, far from space and time, breathing the eternal atmosphere that, in works of art, bathes the figures that a painter who lived but a day has created.

Every young, restless artist who is looking for new paths to follow, who goes to England and falls into a daydream while looking at *Briar-Rose* or *Love and Death,* resembles this sleeping knight. Not in the sense that he is caught between good and evil, between duty and pleasure, but in the sense that two forms of art call to him, and these are but divinities or illusions in a dream.

Ophelia

John William Waterhouse, 1910
Oil on canvas, 102 x 64 cm
The Pre-Raphaelite Trust, London

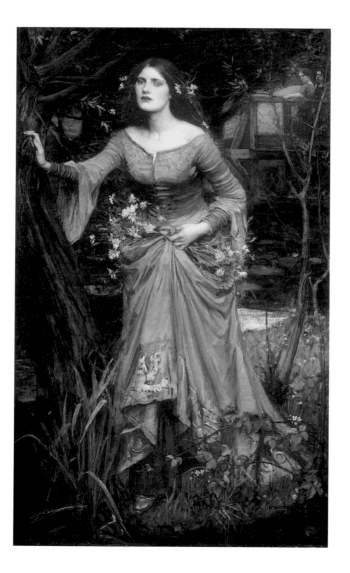

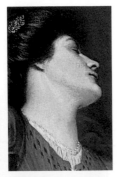

On one side, Burne-Jones's nymph offers him the myrtle of legend, and on the other, Watts' virtue offers the naked sword of morality. If he follows either of them, he will certainly be lost. May he look instead to the background, to those winding paths, curving valleys, blue-tinged mountains, and flowing waters. May he return now and always to nature, the only counsel that one may listen to without suspicion, the only enchantress that one may follow without remorse. The English painters were great tempters; let us admire them, not imitate them.

"I am half-sick of shadows",
said the Lady of Shalott

Sidney Harold Meteyard, 1913
Oil on canvas, 76 x 114 cm
The Pre-Raphaelite Trust, London

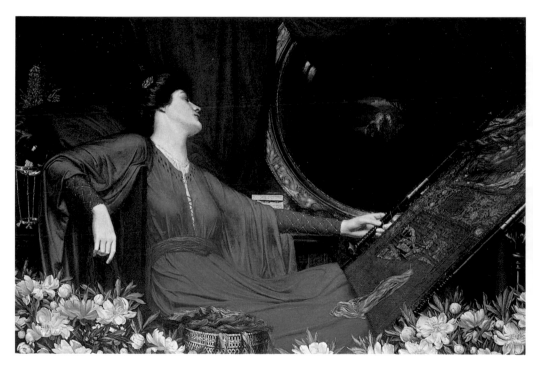

Index